WATERCOLOR FOR THE *fun* OF IT
Flowers&Leaves

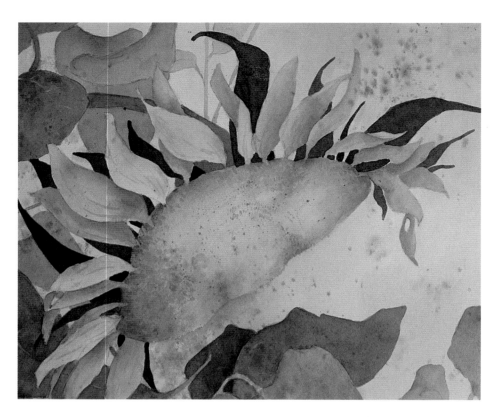

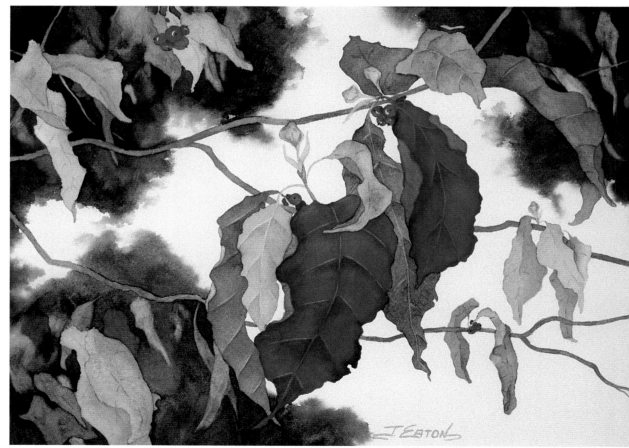

WATERCOLOR FOR THE *fun* OF IT

Flowers&Leaves

Judy Eaton

NORTH LIGHT BOOKS
CINCINNATI, OHIO
www.artistsnetwork.com

Judy Eaton was raised in Indiana and spent her youth tramping through the woods on her grandmother's farm. Although she bought her first fine-art print at age twelve, a Rembrandt reproduction, she never thought she could paint. Sensibly, she got a B.A. from Indiana University and an M.A. from Butler University, both in English, married and became a high school English teacher.

Her career in art began with a maternity "retirement." Friends urged her to go to painting classes with them, and many classes, seminars and workshops followed. In the 80s Judy began to paint professionally, exhibiting and selling her work in shows and galleries. She juggles two full-time careers, painting and teaching. She says they complement each other well because making art with words and making art with paint have a great deal in common– structure, variety and repetition, texture, style, content. She also teaches watercolor workshops.

Judy lives in southeastern Indiana with her husband, Larry. You can reach her at jeaton@seidata.com.

Other fine North Light Books are available from your local bookstore, art supply store or direct from the publisher.

07 06 05 04 03 5 4 3 2 1

Library of Congress Cataloging-in-Publication Data
Eaton, Judy (Judith S.)
 Watercolor for the fun of it: flowers and leaves/Judy Eaton.--1st ed.
 p. cm.
 Includes index.
 ISBN 1-58180-235-8 (pbk.)
 1. Flowers in art. 2. Leaves in art. 3. Watercolor painting--Technique. I. Title.
ND2300 .E37 2003
751.42'2434--dc21 2002030937

METRIC CONVERSION CHART

to convert	to	multiply by
Inches	Centimeters	2.54
Centimeters	Inches	0.4
Feet	Centimeters	30.5
Centimeters	Feet	0.03
Yards	Meters	0.9
Meters	Yards	1.1
Sq. Inches	Sq. Centimeters	6.45
Sq. Centimeters	Sq. Inches	0.16
Sq. Feet	Sq. Meters	0.09
Sq. Meters	Sq. Feet	10.8
Sq. Yards	Sq. Meters	0.8
Sq. Meters	Sq. Yards	1.2
Pounds	Kilograms	0.45
Kilograms	Pounds	2.2
Ounces	Grams	28.3
Grams	Ounces	0.035

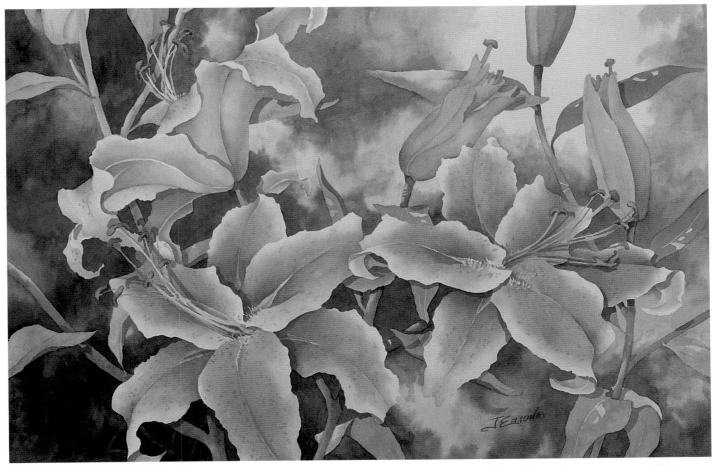

These flowers always seem to send their spirits—and ours—soaring to the heights. You'll learn how to create your own interesting stargazer composition in a simplified step-by-step demonstration in chapter three.

STARGAZERS • 22" × 30" (56cm × 76cm)

Dedication

To my husband, Larry. Without you, there would be no book and I would be no artist. Thank you for your time, energy, encouragement, patience and the countless ways you have helped and supported me.

Acknowledgments

Thanks to my editor, Bethe Ferguson, who kept me going through all the details, problems and questions, and who was always there when I needed her. Thanks also to Pam Wissman, who suggested the idea and started the whole process. To George Limback and Matrix Photo Lab, who took such good care of my slides. To all the teachers I have had along the way, thank you for your talents and your willingness to share them with all of us.

A special thanks to Nita Leland, whose books and articles taught me so much about color and color mixing. And thanks to my family and friends, especially to Kristy, Paul, Nick and Stacy, who remained my faithful supporters even when I was too busy to come out and play.

Table *of* Contents

1) painting BASICS

Master the basic building blocks of a painting! Learn simple tips that will start you on your way to painting like a pro in no time flat. Explore composition, color fundamentals, brushwork and basic painting techniques. You will also learn how to use reference materials and how a working knowledge of positive and negative spaces can help you to make the most out of your blank paper.
page 14

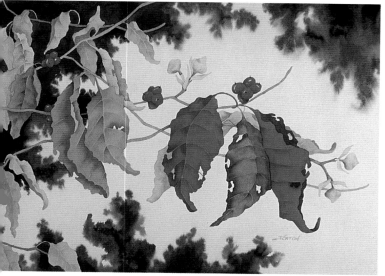

2) painting LEAVES

Capture the spirit of nature! Some of the best colors and compositions are just waiting outside your window. See how to mix greens and other color combinations that will produce a multitude of fascinating shades. Master a variety of leaf shapes and try your hand at a grapes-and-leaves demonstration. Discover how to paint dark backgrounds with a wet-in-wet technique and how to use glazing. Practice your knowledge with four mini demonstrations and four step-by-step paintings. **page 30**

3) painting FLOWERS

Create five fabulous flowers that will last year-round. Use masking fluid, ruffles, bends and layered backgrounds to compose beautiful paintings. Further your knowledge of wet-in-wet techniques for backgrounds and let your creative side soar as you use reference photos to lead you into the magical world of watercolor! Loosen up and absorb all the lessons with five step-by-step paintings, one mini demonstration and a bonus lesson on hot-pressed paper.

page 60

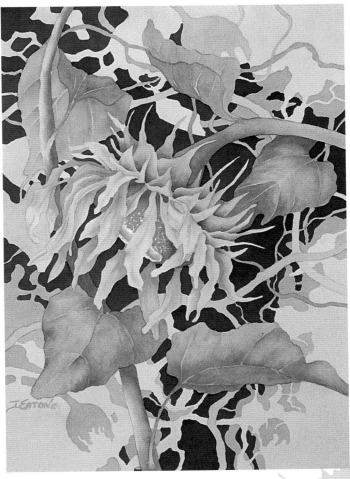

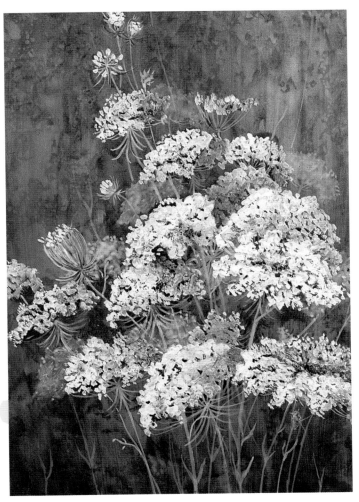

Introduction

During a maternity retirement, my friends talked me into taking tole painting lessons with them. When they decided to try watercolor, I stayed home because I knew that it would be too hard for me to do. But when they came home with some nice work, I couldn't stand to be left out, so I tagged along with them. When I saw that flow of beautiful, transparent color glowing on white paper and the magic mingling of one color with another to create still a third, I was hooked. I went from someone who thought she could only appreciate art to someone who had to paint! My education came from my own trial-and-error painting, seminars and workshops, classes and many books just like this one. Maybe you have had a similar experience and that's why you're holding this book right now. ◎ I have made two fantastic discoveries about art along the way. The first is this: Anyone can become proficient at making art, even if you can't draw a straight line. And anyone can understand the techniques taught in books or by teachers. It just takes putting miles on your brush to make them happen in your own work. The knowledge goes into your mind a lot faster than it comes out of your brush. ◎ The goal of this book is to explain the basic techniques that will help you become a better painter. Then you will follow several step-by-step demonstrations, which will put those miles on your brush. Although the subjects of this book are flowers and leaves, the lessons and techniques you will learn can be adapted to fit any other subject. You will start with simple forms and tips and build from there. More complex forms are really just several simple forms grouped together, so it's not so hard after all! We'll even learn ways to control and correct watercolor, but don't tell the uninitiated that it's not the hardest medium after all. Just let them be awed that you can handle watercolor. You will also explore a variety of ways to paint and the materials that will help you create art from the images in your mind. ◎ The second fantastic discovery I made—and probably the most important—is that making art is really a thing of the head and heart, not the hands. Once you learn the basic techniques of painting, then you can start learning to be an artist. That entails putting your own personal understanding of and reaction to your subject onto paper. Being true to your own personal vision is the thing that really counts! The technical stuff is only a way to communicate, just as words are only a means to tell what's in our hearts and souls. ◎ What wonderful subject matter on which to learn! Flowers and leaves combine beautiful colors and sensuous contours. They're almost as fun to paint as nudes, but sometimes more socially acceptable to the Aunt Ethels of the world. When you're done with this book, you'll probably have some nice paintings and maybe a few pieces of paper whose backs will be good for try-out sheets. You will have learned a lot from both, and the joy is in the learning. Let's get started on the fun!

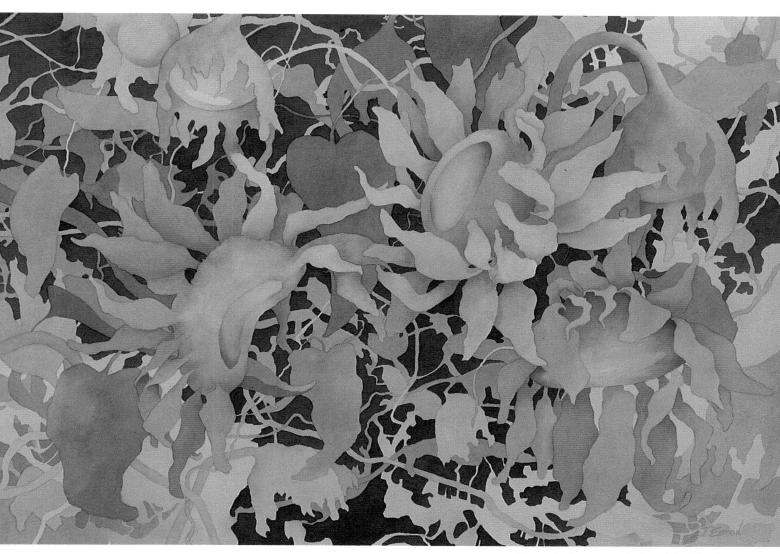

The main shapes were in the original drawing, but the rest were picked out as each of many background layers were painted with the technique described in demonstrations in chapters two and three.

MIND/SIGHT • 22" × 30" (56cm × 76cm)

A Quick Start Guide

GLOSSARY OF TERMS

Complements two colors that are directly opposite on the color wheel

Composition the placement of all the elements in a painting so that they form a pleasing relationship

Damp brush a brush loaded with paint, but blotted at the ferrule to remove excess water

Daubing touching the brush tip to the paper repeatedly, leaving many small marks

Drybrush holding a brush horizontally and dragging it across the paper so that it deposits paint only on the paper's high points and gives a broken-line effect

Hue the name of the actual color (e.g. blue)

Lifting color (or "wiping out") removing pigment by gently scrubbing with a damp brush and then blotting

Local color the actual color of an object

Masking using masking fluid, tape, etc. to protect portions of paper and preserve the whites

Negative shapes or space the shapes that represent the space around the actual physical things in the composition

Positive shapes or space the shapes that represent actual physical things in the painting, such as trees, apples, people

Primary colors red, yellow and blue—the colors from which all others are made

Run back an area where wet paint is pulled back into a drying area, resulting in a lighter space surrounded by a circle of more intense pigment

Spattering depositing water or paint onto a wet paper by loading the brush and making a quick, downward motion with your whole arm to flick spots of liquid onto the wet surface

Temperature the amount of yellow or blue in a color—blue-green is a cool green, while yellow-green is a warm green

Under painting (or "base painting") painting an area first with light colors that will influence the final color in transparent watercolor

Value the darkness or lightness of a color, usually ranging from one (white) to ten (black)

Wet-in-wet a technique in which wet paint is applied to wet paper

There are many brands of painting materials on the market today, and art supply stores usually have knowledgeable people who can steer you toward the good products. After painting a while, you will probably settle on your favorite brands because you will know what to expect and are comfortable with them. I am recommending the materials that I am comfortable with, but feel free to substitute.

Palette

You will need a large, watercolor palette and an extra three-well small palette. I use the John Pike Watercolor Palette. A good palette has many color wells, lots of mixing room and a lid that can provide even more mixing room. A large, white tray will do, but a good palette is much better. A supplementary small three-well mixing palette with a thumb hole is very handy for carrying puddles of paint closer to the paper. Purchasing artists' grade, not student grade, materials will give you the best results.

Paper

You will need 140-lb. (300gsm) cold-pressed watercolor paper, tracing paper, wax-free transfer paper and one sheet of 140-lb. (300gsm) hot-pressed paper for the last demonstration.

I use Arches 140-lb. (300gsm) cold-pressed watercolor paper. "Cold pressed," a term referring to the smoothness of paper, is the easiest to paint on because it's not too bumpy or too slick. The weight, 140-lb. (300gsm), gives you a paper that is not terribly expensive, but is thick enough to withstand lots of washes and some scrubbing.

You will also need tracing paper for composing more intricate drawings. A complex composition is best worked out on tracing paper, then transferred to your watercolor paper once you are satisfied. Your tracing paper can also be a great guide to the faint lines you must draw on watercolor paper.

Transfer paper allows you to transfer your composition from the tracing paper to the watercolor paper. You can transfer a drawing by scribbling on the back of it with your pencil, laying the drawing on watercolor paper and retracing, but wax-free transfer paper is easier to use.

Paints

I recommend Winsor & Newton Artists' Watercolors for your basic palette.

I use this brand throughout the book, and although paint names may be specific to each brand, you can generally find pretty close alternatives no matter what you buy. These colors will give you the bare essentials:

- Burnt Sienna
- French Ultramarine Blue
- Hooker's Green
- New Gamboge
- Permanent Alizarin Crimson
- Sepia
- Winsor Blue (Green Shade)
- Winsor Lemon
- Winsor Red

For a really nice palette, add:

- Antwerp Blue
- Cadmium Orange
- Permanent Rose
- Quinacridone Gold
- Sap Green
- Winsor Blue (Red Shade)
- Winsor Violet

Extra colors that are a joy to have:

- Cerulean Blue
- Cobalt Turquoise
- Raw Sienna
- Winsor Green

Brushes

A good brush will spring back to shape after you wet it and mash one side down on paper. Kolinsky sable brushes are supposed to be the best, but they are very expensive. A good substitute for sable is the Winsor & Newton Scepter Gold series. Here are the basics you will need for the demonstrations in this book:

- ◎ No. 4 round
- ◎ No. 6 round
- ◎ No. 8 round
- ◎ Two no. 10 rounds
- ◎ 1-inch (25mm) flat
- ◎ Cheap, hard, small bristle brush for scrubbing
- ◎ A few extra round brushes are a nice addition

Other Supplies

- ◎ Three water holders—plastic storage containers work well
- ◎ Light, sturdy support board or drawing board approximately 15" × 22" (38cm × 56cm)—Gator board, basswood or foamcore
- ◎ Acid-free masking tape
- ◎ Clean spray bottle of water
- ◎ Clean sponge
- ◎ No. 2 pencils
- ◎ Something to prop your support board up 1- to 2- inches (3cm to 5cm)
- ◎ Gray, kneaded eraser
- ◎ Roll of toilet paper
- ◎ Good paper towels
- ◎ Hair dryer (optional)
- ◎ Wax-free transfer paper especially for watercolor (optional)

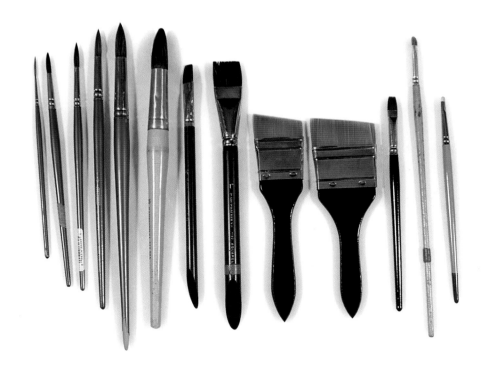

My Private Collection

This is a selection of some of my brushes, but you don't need all of these to get started. (Listed in order from left to right: No. 00 rigger, no. 6 round, no. 8 round, no. 10 round, no. 14 round, no. 26 round, ½-inch (12mm) flat, 1-inch (25mm) flat, 1½-inch (38mm) chisel, 2-inch (51mm) chisel, soft scrubbing brush, old oil brush for hard scrubbing and a fritch scrubber.)

I use the nos. 6, 8 and 10 rounds for the bulk of my work, but the 1-inch (25mm) flat is invaluable for painting large areas. The black-handled soft bristle brush is great for scrubbing out areas you don't want to damage, and since it is a flat brush it scrubs out thin lines very well.

Preparing Your Equipment

Arranging your painting equipment is very personal and very important. Things need to be arranged so that they work together well, and then they need to stay in the same place so that finding them is automatic. You don't want to be looking for something while your paint is drying.

Preparing Watercolor Paper

Stretching

Soak your watercolor paper thoroughly with water. Then place it on a board (Gator board, basswood or foamcore) and staple it down. When it dries, it will shrink tight and not buckle when you put water on it. This is the recommended way to prepare paper, but I find it burdensome.

Taping

My favorite way to prepare paper is simply to use acid-free artist's masking tape to tape the paper directly to the board. Wash the paper lightly with a sponge full of clean water to remove some of the sizing (a gelatin-like substance that controls the absorbency of paint into the paper) and let the paper dry. Never erase anything on unwashed paper. You will change the sizing in that area, and the paper will accept the paint differently. Washing also helps the paint go on more easily.

Getting Ready to Paint

Before you begin any painting, you must follow a few rules to insure that you will get the best possible results. I will refer to this process (as the Getting-Ready Step) many times throughout the book.

- Stretch or tape your paper.
- Wash the paper lightly with clear water and a sponge.
- Transfer your drawing by using your pencil edge to scribble on the reverse side of the drawing or by using watercolor transfer paper.
- When you are finished, check your drawing carefully to be sure that it is all there and that you can tell the positive and negative areas apart.

The Setup

You will quickly realize that there are a few essential items for painting besides the typical paint, palette and brushes. I always have paper towels on hand for spills, a spray bottle to moisten paint, containers for clean and dirty water and a selection of sharpened pencils. Once you find a setup that works well for you, leave it alone! You will soon memorize where everything is, then you can quickly grab items without having to leave your painting and waste time searching for them.

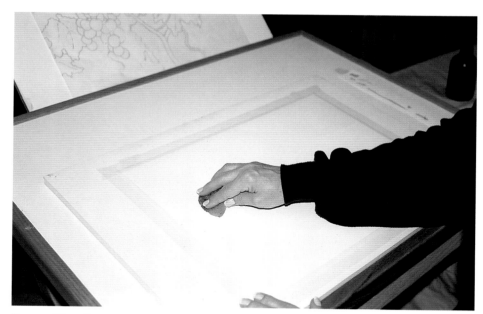

Prepare Your Paper

Taping your paper to a board is a quick and easy way to keep it from buckling while you paint. Be sure to lightly sponge off the sizing before you apply any paint.

Here, I am in the midst of completing the "Getting Ready Step." Notice how I keep my original drawing close at hand. This is so I can easily reference my composition, even if the sketches on my paper are covered with paint.

Anatomy of a Flower

Throughout the book I will be instructing you to paint certain areas of the flower, such as anthers, stamens and sepals. These may be terms that you vaguely remember from your botany class, but don't go looking for that old textbook yet! Keep this anatomy chart handy at all times. You can even copy it and place it next to your painting. This quick anatomy lesson will give you insight into the makeup of almost every flower, allowing you to feel more confident with any composition.

Helpful Tips Before You Start

⚘ If you tape your paper, remember that tape will cover about ¼-inch (.6cm) and that you will want to cover another ¼-inch (.6cm) with a mat if you frame your painting. I usually work on paper that is 1- to 1½-inches (3 to 4 centimeters) larger than my matted, finished painting will be. If you want a 12" × 16" (30cm × 41cm) image, paint it on a 13" × 17" (33cm × 43cm) paper, which will allow you some breathing room for taping and matting.

⚘ Some artists believe in squeezing fresh paint for every painting session, but you can keep your paint for a long time if you use a spray bottle to moisten your paints when you begin a session. In just a few minutes, dry paint becomes very workable.

⚘ After painting, do not close your palette tightly. This can lead to mold on your paints.

⚘ To blot your brush, use a roll of toilet paper wrapped with three paper towels still attached to each other and folded in half. When they get too wet or dirty, throw the towels away, let the toilet paper dry, and wrap it again.

⚘ Use three water containers—one for washing out the brush, one for swishing it in clean water and one with absolutely pristine

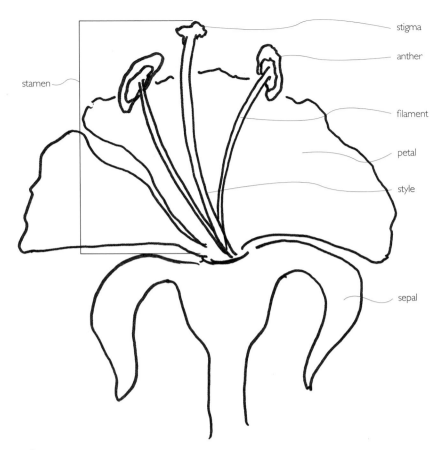

Anatomy Lesson

Study this crosssection of a flower. Understanding basic flower anatomy will help you quickly identify the various areas I will refer to in the demonstrations. This anatomy lesson contains common elements you can use to help you tackle even the most complex flower compositions.

water to be used in an emergency. You can paint all day without changing water.

⚘ Keep paper towels folded and ready to grab in case of spills or other mishaps.

⚘ Mark some of your favorite brushes with tape so you can always find them immediately.

⚘ Buy an additional small palette for trying out new colors.

⚘ Arrange your equipment so that you don't have to drag things back and forth over your painting.

⚘ Find a setup that works for you, and keep it in place so you never have to look for anything.

1 painting BASICS

Before you begin to paint, you need to spend a little time thinking about the basic building blocks of a painting. When I started to paint, I just tried copying pictures, greeting cards or my teacher's paintings. I learned the basics by trial and error. Half of the time I knew the work could be better, but I didn't know exactly what could be changed. Sometimes I knew what was wrong but I just didn't know how to make it right. There is a better way! So let's take a quick look at just a few of the basics.

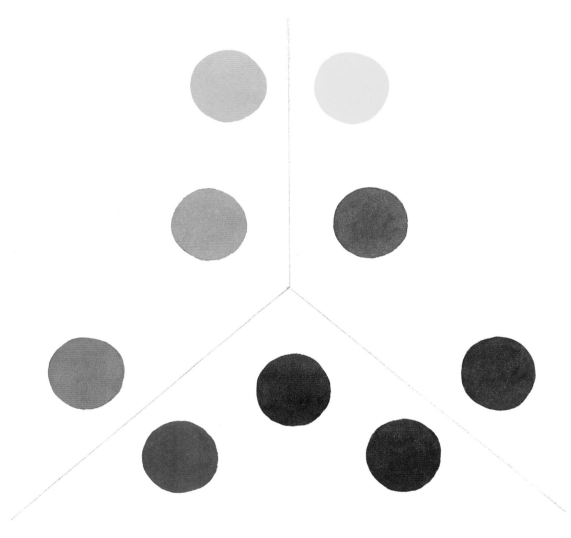

Reinvent the Wheel
Color is one of the most important elements in a painting, and color wheels are invaluable tools that will help you discover a wealth of information. Although there are many store brands you can buy, I recommend that you make your own color wheel. Painting your own wheel will help you dive right into color mixing, and you'll learn a lot about color relationships.

Reach *for the* Stars *in* Your Compositions

Composition is the arrangement of your subject and supporting details within the frame of your paper. Think of your painting as having a star (the main subject area, which is the center of interest) and a supporting cast (the details). You have to keep the star in the spotlight while balancing the supporting cast so that the stage looks interesting. There are lots of terms for where the spotlight shines the brightest, but the one I love the best is the "sweet spot." The sweet spot can be above, below, left or right of the center, but usually not in the center. If you put your star in one of these spots, you will have a much easier time arranging a good composition. Spotlight your center of interest by using as many of these techniques as you can:

- **Position**—Put the main subject in a sweet spot.
- **Hardest edges**—Use sharp and well-defined edges on the center of interest.
- **Most brilliant color**—Don't let any other large areas of the painting be as bold in color as the center of interest.
- **Greatest value contrast between light and dark**—Other large areas should not have as much value contrast as the center of interest.
- **Largest size**—Make your star the largest leaf, flower, etc.

Sometimes the key to creating interesting compositions lies in twisting, turning, grouping or overlapping shapes. The most basic rule to keep in mind when you are planning your painting is that variety is the spice of life! Sometimes it's an asset to not be able to draw a straight line because straight lines are boring. Interesting, wiggly lines express your own style and uniqueness. On the next two pages you'll see visual references that will guide you to better compositions.

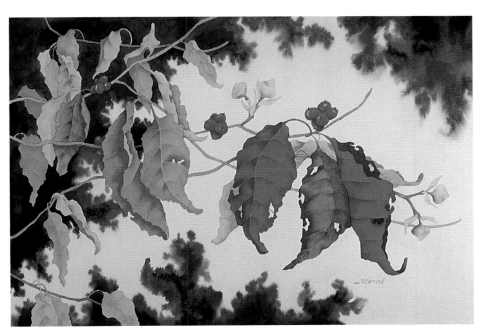

The Sweet Spot
Can you see the sweet spot in this painting? It is the red and green leaves to the right of the center. Placing these two complementary colors side by side effectively draws your attention away from the center.

Go Beyond Boring
This drawing is compositionally boring. The leaves are shown only in silhouette, the lines are too perfect and the two edges of the leaves come together, forming a tangent called a "kiss." They are also too similar in size and basic shape, and the tips point to the corners of the rectangle.

Add a Twist
With a few twists this simple drawing became a much more interesting snippet. Notice the irregular, more exciting lines. There are no kisses, the shapes overlap, giving a sense of depth, and nothing points to the corners. Also, I have added some inside areas of leaves peeking out.

Shape Your Spaces

In any painting, the interplay of positive and negative spaces can make or break your composition. Study these examples and learn some quick tips that will help you whip your composition into shape.

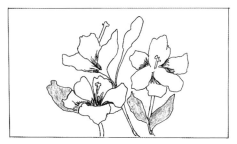

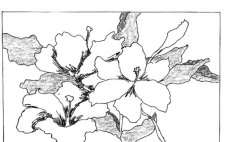

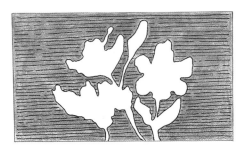

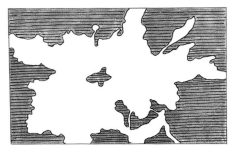

Consider Composition

In the top composition, you know you are off to a bad start immediately. You'll need a lot more flowers to fill the space, but none of them will be the star. There is not enough overlapping, so the composition seems spotty. Since nothing goes to the edge, there will be too much background. The negative space (the empty space around the flowers) is not broken up by enough positive areas (the space taken up by actual physical items).

The bottom composition is not perfect, but it's much better. There are an odd number of larger flowers, and they fill the space more appropriately. There is a lot of overlapping, which creates depth and connects the positive shapes. The bud is overlapped only at the bottom; it will probably need more connection, unless the background will serve as a connector somehow. There is a more interesting variety of shapes. The image touches the edges on all four sides, intersecting each edge in a different place.

Positive and Negative Shapes

Here are the positive and negative shapes from the drawings on the immediate left. The negative spaces are just as important and exciting as the positive shapes. They need an equal amount of attention, so let's take a closer look at them. The negative spaces are the dark areas in this illustration, and the positive spaces are the white areas.

The positive spaces are very spotty and unconnected in the left composition. The negative space is unbroken and the same on three sides. This is boring!

In the composition on the right there is a definite flow of positive space from the upper part of the left side to the middle part of the right side. It also flows from top to bottom. This flow is what makes the negative space interesting. Imagine cutting out the negative space from each corner and looking at it as a shape. How much more interesting it is than the negative space in the left composition!

Negative Shapes Pack a Wallop

Here, the negative spaces from each corner of the composition on the right are treated like individual shapes. None of the straight lines are the same size, and all four shapes are quite different.

Consider Color

Entire books have been written about color, so we are just touching the surface here.

Color is, of course, one of the most important elements in a painting. It is also one of the most personal statements a painter makes. Nita Leland's work in *Exploring Color* (revised edition) taught me the importance of color temperature and how to divide the whole wheel into three parts. This division will help you understand how temperature affects the colors you mix. If you don't have a color wheel, get one. Better yet, paint one. It will teach you a lot about color and color mixing.

The Language of Color
The first thing you must do is to establish a working knowledge of the basic vocabulary of color. Here is a simple glossary to get you on your way.

- **Complements**—Two colors that are directly opposite on the color wheel. Technically, these two colors contain all the colors on the wheel since they are opposite each other. That is why mixing complements results in a neutral grey color.
- **Hue**—The name of the actual color of something (healthy summer grass is green).
- **Intensity**—The brilliance of a color (light pink versus bright red)
- **Mud**—An ugly, dark color that has no life to it. This is what you want to avoid.
- **Primary colors**—Red, yellow and blue. These are the three colors from which all others are made.
- **Value**—The darkness or lightness of a color (in a black-and-white photo of a yellow and blue checked tablecloth, the yellow would appear light and the blue much darker).
- **Warm or cool**—A relative term. Warm colors tend more toward yellow and cool colors tend more toward blue. Check the color wheel.

Color Wheel Know-How
Three primary colors make the basis of the color wheel. This wheel shows a warm and cool version of each color because the temperature of the color will affect the paint you mix.

How to Make the Color You Want
The primary colors of yellow, blue and red make up the first step in the color wheel. Each one is shown in a cool and warm version. Remember that warm and cool are relative terms. For example, contrast New Gamboge and Winsor Lemon. New Gamboge seems more closely related to red than Winsor Lemon, so New Gamboge is warm, while Winsor Lemon is cool. You can also see that Winsor Red has more yellow in it than does Alizarin Crimson, so Winsor Red is warm and Alizarin Crimson is cool. French Ultramarine Blue has a cool purple cast caused by the red in it, while Winsor Blue (Green Shade) has more yellow in it, so it is warm.

Understanding how warm and cool colors affect the mixtures you make will allow you to make the kinds of colors you want. Notice the lines between the colors on the wheel. If you want clear colors with high intensity, mix colors that are within one section of the color wheel. Each of the secondary colors (green, purple and orange) have been mixed from the colors within their lines and are bright and clear. So Aureolin and Winsor Blue (Green Shade) produce a clear green, but New Gamboge and French Ultramarine Blue would produce a green that is more gray and has lower intensity of color.

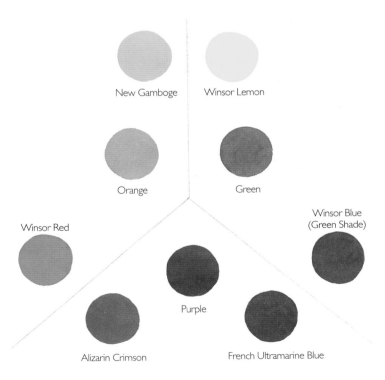

New Gamboge Winsor Lemon

Orange Green

Winsor Red Winsor Blue (Green Shade)

Purple

Alizarin Crimson French Ultramarine Blue

The Necessary Color Know-How

The only way to become friends with your colors is to use them! Get acquainted with each new color by mixing it with others to see what happens. If you really want to understand a color, make a mixing chart. You can even use the back of a painting you would rather forget. First, put down the colors you are working with and label them. Next, check the permanence of each color by scrubbing out a portion, and see how much you can return the paper to white. Then, paint a strip of the pure color you intend to mix into them. Mix them and paint an example of the mixtures. Experiment with as many mixtures as you want.

COLOR IN A NUTSHELL

- To mix clear color, stay within a color section and do not cross the line.
- To gray the color or lower its intensity, cross the line in the colors you mix.
- You can also gray a color by mixing in a bit of the original color's complement.
- Mud happens when you cross the line and make the pigment mixture too heavy, when you put too many colors in the same mixture or when you glaze too many times with colors that cross the line.
- Set up your palette in a way that makes sense to you and keep it that way so you don't have to hunt for the right color when you need to be thinking about the painting itself.

Cool vs. Warm
A color mixing chart will help you understand how your colors work best. This one compares a cool blue and a warm blue.

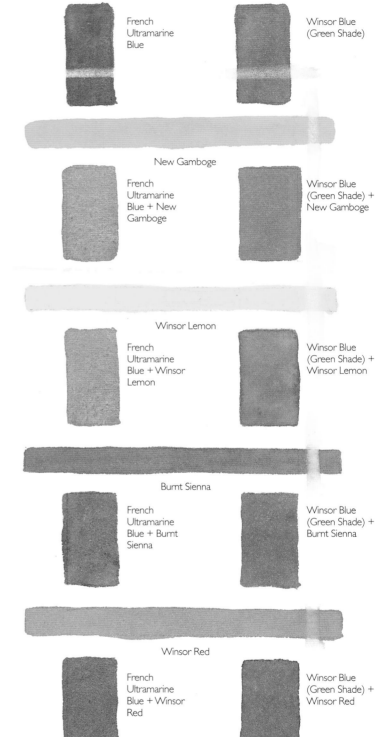

French Ultramarine Blue

Winsor Blue (Green Shade)

New Gamboge

French Ultramarine Blue + New Gamboge

Winsor Blue (Green Shade) + New Gamboge

Winsor Lemon

French Ultramarine Blue + Winsor Lemon

Winsor Blue (Green Shade) + Winsor Lemon

Burnt Sienna

French Ultramarine Blue + Burnt Sienna

Winsor Blue (Green Shade) + Burnt Sienna

Winsor Red

French Ultramarine Blue + Winsor Red

Winsor Blue (Green Shade) + Winsor Red

Mix *and* Match Your Colors

There are three ways to mix color, and each will give you very different results. Experiment with each option to find how to best create the colors for your paintings.

Mixing color on the paper itself produces exciting color effects. You simply make a puddle of each color you will use, paint one and then paint the other directly into the first using the wet-in-wet technique explained in the glossary section on page 10.

Mingling color on the palette is an exciting way to mix also! You make a puddle of one color and then put the second color into the puddle in a random fashion. Swish through the puddle with your brush once or twice and paint. The colors are partially mixed and will mix more on the paper because they are both wet. This retains the excitement of mixing on the paper, but the result is more subtle.

Mixing color on the palette is the technique that you will use most often, reserving the other techniques for special areas. It produces a nice, smooth color, which works very well. Be careful to stir the mixture often so it doesn't separate. Add a bit of water when the mix seems to be getting a little darker, because water evaporation will change the ratio of pigment to water.

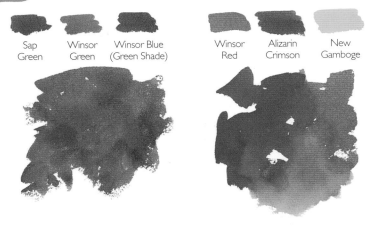

Sap Green · Winsor Green · Winsor Blue (Green Shade) · Winsor Red · Alizarin Crimson · New Gamboge

Paper is Perfect for Related Colors
Mixing color on the paper works even better with more closely related colors.

Tip The color mixture you see on your palette may be a big surprise when you put it on paper! It's handy to have a piece of trial paper beside your painting to test each mix before you actually use it.

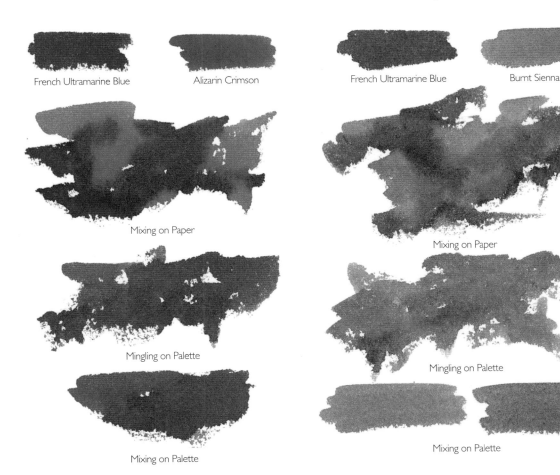

French Ultramarine Blue · Alizarin Crimson

Mixing on Paper

Mingling on Palette

Mixing on Palette

French Ultramarine Blue · Burnt Sienna

Mixing on Paper

Mingling on Palette

Mixing on Palette

Mix it Up
Here you can see how each of the three ways of mixing will give you different results.

Brushwork Essentials

Brushwork is one of the most important aspects of painting, so it's essential that you get comfortable with what your brush can do before you try to tackle any exercise. With practice, anyone can learn the techniques of painting. The more you use your brush, the more it will become an extension of your mind. When making the mark becomes an automatic action, you will be free to think about the whole meaning of your painting instead of worrying about the technical aspects. The effective communication of meaning is what makes the difference between a good painter and an artist.

The position of your paper will make a big difference in how your pigment flows. Some artists paint with their paper flat on a table, while others like to use an easel. Some put their support board on a table and prop the top up so that the paper is at a slight angle. This allows gravity to keep the wet paint flowing gently toward the bottom of the paper. This method offers the most control for the beginner. Whatever method you choose, stick to it until you understand exactly how the paint will react. Later you can experiment with other positions, which create a variety of effects.

No. 6 Round Brush

First, hold the brush almost vertically, so that only the tip touches the paper. For the next two strokes, hold the brush at an angle similar to the angle you would use to hold a pencil. This is the most commonly used brushstroke. In the last example, called drybrushing, blot the brush, hold it almost horizontally and drag it across the paper. Since the paper is not completely smooth, the paint is deposited only on the high points, making this special effect. It is very useful for giving texture and glisten.

No. 6 Round Brush

Here are some marks you can make with a no.6 round brush held at the angle you would hold a pencil, but hold it further up on the brush handle. Use it as if you were writing.

½-inch (12mm) Flat Brush

This shows marks made with a ½-inch (12mm) flat brush, so only the thin edge touches the paper. Next, the broad side was used. The last two strokes were drybrushed as in the first example

½-inch (12mm) Flat Brush

You can make the same marks with a ½- inch (12mm) flat brush as you can with a round brush, but notice how different they are. The flat brush can perform almost like a broad calligraphy pen.

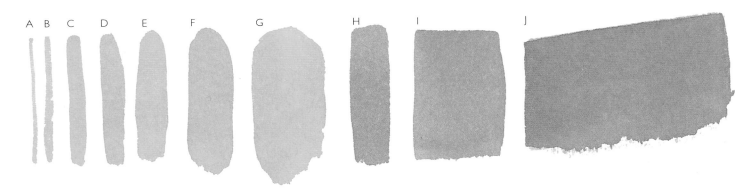

Riggers, Rounds and Flat Brushes

Here you can see the marks made by different-size brushes. Use a (A) no. 2 rigger, held vertically, to make the thinnest line. For the next eight strokes, hold the various brushes the same way you would a pencil: (B) no. 2 rigger, (C) no. 6 round, (D) no. 8 round, (E) no. 10 round, (F) no. 14 round, (G) no. 26 round, (H) ½-inch (12mm) flat, (I) 1-inch (25mm) flat and a (J) 2-inch (51mm) chisel.

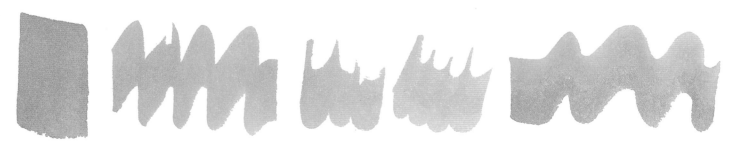

½-inch (12mm) Chisel Brush

Here is my newest brush, a ½-inch (12mm) chisel. In the last mark I double loaded the brush by dipping one corner in the first color and the other corner in a second color. Go ahead and try a variety of colors. It can be a lot of fun to see what can happen!

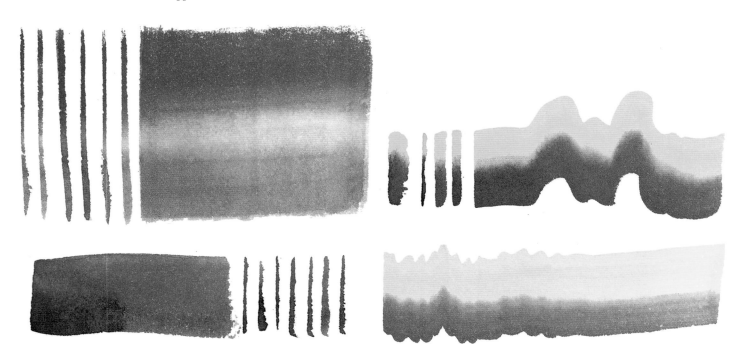

Flat Brushes

These examples use a a 2-inch chisel (51mm) brush (top) and ½-inch (12mm) flat brush (bottom), each one was double loaded. Make the broad lines by holding the brush at a slight angle and slowly pulling across the paper. The large brush wasn't loaded well enough, so there is an absence of paint in the middle. To make the thin lines, hold the brush vertically and touch only the edge to the paper and lift back up.

1-inch (25mm) Flat

The 1-inch (25mm) flat brush is a nice size to double load. To make the thinner marks, hold the brush vertically and touch only the long thin edge to the paper. For the wavy lines, simply wiggle the brush up and down as you paint across the paper.

Five Ways *to* Spoil *a* Stroke

As I mentioned before, practice makes perfect, so keep putting those miles on your brush. Here are five surefire ways to spoil any stroke:

1. This stroke was not touched at the bottom with a thirsty brush. A thirsty brush is one that has less water in it than the painted spot that you are going to touch it to. Therefore, it will soak up paint rather than release paint. When you use watercolor, sometimes there will be a bead of paint and water at the bottom of the area. If you do not pick up this bead with a thirsty brush (one that has been blotted, but not rinsed), the paint will begin drying from the top down. Then the more watery paint left in the bead at the bottom will soak up into the drier area and you will get a run back or balloon.

2. I made this stroke, rinsed and blotted the brush—instead of just blotting it—then picked up the bead at the bottom of the stroke. That diluted the paint and the clear water ran back up the stroke until it reached a dry barrier.

3. This stroke was touched again at the top with diluted paint or clear water.

4. This stroke was half dry when it was touched again at the bottom.

5. Be sure you know the staining nature of your color. Nothing is worse than trying to scrub out a color that just won't budge. Here you can see the degree to which you can wash off color by lightly scrubbing it with a brush filled with clear water and blotting it.

As you can see, some paints are more staining than others. Gentle scrubbing with a soft brush causes little harm to the paper. Let the spot dry completely, smooth it with an angled brush handle (or the back of a spoon) and you can probably paint over it with no ill effects. Harder scrubbing, however, will abrade the paper and make painting over the area impossible to disguise. Use harder scrubbing only as a last resort at the end of the painting and only if you do not plan to repaint the area.

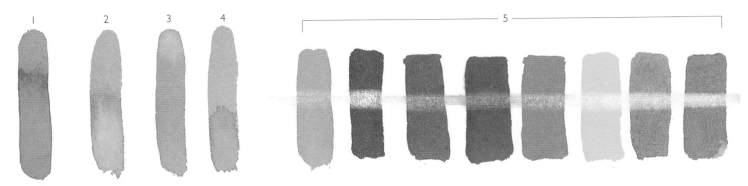

Learn to Save Time
Save yourself time and energy by studying these five common problems. The complete descriptions are listed above.

Tip To get a thirsty brush, simply blot your brush well, and then touch the bead to pick up the extra water. You can do this more than once if the area is large.

Powerful Painting Techniques

These are the basic techniques for every watercolor enthusiast. Take a few moments to practice each of them. The first two are variations of painting wet in wet, which simply means putting wet paint onto an already wet surface. That surface may be a wet, blank paper or a paper that has just been painted and is still wet. Either way, it's one of my favorite methods. To make this technique work well, you need to have a smaller ratio of water to the paint in your brush than the ratio of water to paint already on your paper. Do this by blotting your brush or even using a paper towel to squeeze some water out of the brush at the ferrule (the place where the brush hairs meet the handle).

Tip You can't paint effectively unless you learn to create soft edges. Often, in fact, they are the only solution to an emergency. When you get in trouble, your paint is drying and you don't know what to do, soften the edge. This allows you time to stop, think and decide the best solution.

Softening an Edge

The first stroke was made on dry paper and all the edges are hard. The second was made and then immediately brushed with clear water across the very bottom of the paint, causing a soft edge as the paint diffused into the wet paper. Practice this to understand how much water should be in your brush for the effect you want. The third stroke was painted into wet paper at the top and softened at the bottom.

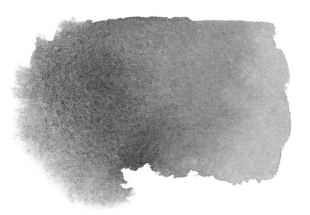

Charging Color

Paint one color and then, while it is still wet, paint another directly into it. To get the best color blend, make your edges ragged rather than straight. Remember to have about the same ratio of water to paint in both colors. This is a great way to blend one color into another!

Glazing

A thin layer of a second color is gently brushed over a first color after it is completely dry. This can be used to modify the first color or to gray it by glazing with the complement. Secrets to success in glazing lie in allowing the first color to dry completely, brushing lightly and using lots of water in the glaze color.

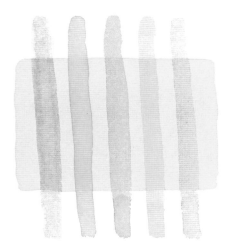

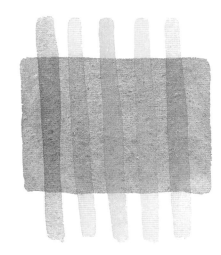

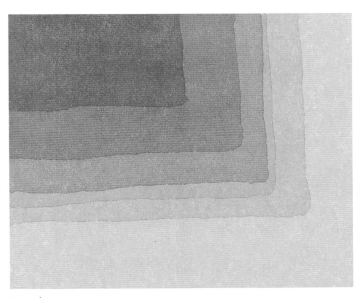

Layering

The same color, in the same intensity, is glazed repeatedly, after allowing the last glaze to dry. There are six coats of red in this example. This is a good technique for increasing the intensity of areas that have dried too lightly or for building up an intense color, which would appear mottled or grainy if you tried to use that much pigment on the first wash.

Laying a Wash

Simply put, this is painting a continuous mass of one color. Practicing this technique will help you understand how to put paint on paper evenly. First, mix a large amount of juicy (plenty of water) color. It shouldn't be light and diluted, just very runny. Prop your support board up an inch or two (two to three centimeters) and make a big, juicy stroke of color with lots of paint forming a pool at the bottom of the stroke (a bead). If you don't have a bead, the paint is not watery enough. Dip your brush into the puddle on your palette, touch the bead at one end and make another juicy stroke. For each stroke across the paper, refill your brush, wash across the bead of the previous stroke and create a new bead at the bottom each stroke. Use plenty of water, touch lightly, work relatively fast, stir the puddle often and you should make a uniform wash.

Tip Always mix about twice as much color as you think you will need because you will be surprised at how fast it disappears!

Grading a Wash

Here you start with full color and work down the paper to no color at all, creating a gradation in the intensity of the color. To begin, use exactly the same technique as in the previous wash. Make a few strokes of full-strength color, and begin grading by adding one brushstroke of clear water and stirring the puddle each time you make another stroke. The color will become more and more diluted until you can barely see it. At that point, stroke on clear water until you can see white paper only. Now you have really learned how to soften edges! Gradation helps you add subtle variety to many areas of your painting.

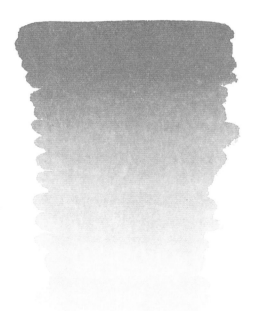

Grading a Hue (Color)

This creates a smooth transition from one color to another. Begin by painting with one color until you establish a bead. Then, instead of adding water to the puddle, add another color a brushfull at a time. When the bead looks more like the second color, add only the second color and your gradation between the two colors will be complete.

Tip Most watercolor pigments dry about 20 percent lighter than they look when you paint them. Remember this as you mix your colors.

Stop Time *with* Reference Photos

There are basically three kinds of reference materials: having the subject directly in front of you, photographs and your own imagination. Some people paint only from life and some entirely from their imaginations, but most of us will use anything we can get.

Painting From Life

The best way to paint from life is to go outside and paint something. That sounds simple, but it requires a lot of lugging, fighting weather and insects, and coping with changing light and time constraints. Don't get me wrong; this is a joyful, exhilarating experience, but it's not easy.

Another way is to bring life into your studio by setting up a still life. You can take your time to study it, compose it and put it under unchanging lighting conditions. Cut the leaves or flowers and have them in front of you. There's nothing better than looking at the real thing as you paint it and being able to see every detail you might need.

Remember that flowers eventually die, so you might want to take some photos of your still life. Leaf compositions do not lend themselves to still-life arrangements, so sometimes you have to hold them up. Be sure that you have some frame of reference for the exact angle from which you are viewing the leaf, so that the next time you hold it up you will see the same thing. I grouped leaves in a jar of water, then kept turning them to get different angles and lighting. Focus on the actual composition. The background can be made from your memory, imagination or photographs.

Painting From Photographs

Generally, the best time of day to photograph flowers and leaves is before 10:00 A.M. or after 2:00 P.M. on a clear, sunny day. (This is dependent on where you live. Try to take photos when the light is bright, but pleasing.) The colors will show to their best advantage and the shadows will be apparent. Be sure to photograph everything that goes with your subject—stems, leaves, branches, buds—and take pictures from lots of different angles. You will need this information in your painting. The great advantage to painting from photos is that you can use them any time and they never change.

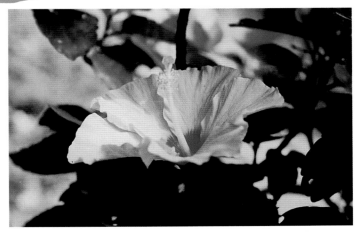

Reference Photo
Hibiscus flower in bloom.

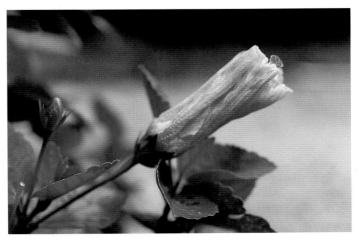

Reference Photo
Hibiscus flower bud (side view).

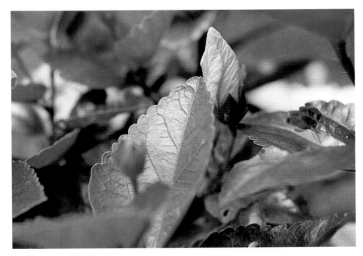

Reference Photo
Hibiscus flower bud (front view).

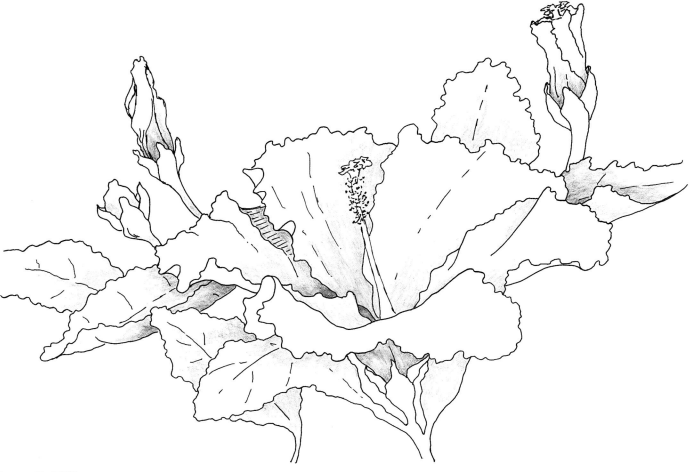

Dare to Be Different

I used the three photos from page 27 to create the drawing of the single hibiscus. As you can see, I took liberties with everything. Many things are exaggerated, but the flower is still quite recognizable. The flower itself is tilted a bit differently, and more of the front petal is curved forward. The two buds getting ready to open are angled quite differently from the pictures, and the small bud is from still another photo. I'm also going to make the colors different in my painting. Use your photos as references, not straight jackets.

TIPS FOR USING PHOTOGRAPHS

- ⊚ Think about all the details when you photograph. You can get a relatively inexpensive close-up lens kit that will screw onto your regular 35mm camera lens and allow you to photograph even the smallest details.

- ⊚ Do the best you can to keep the light source coming from the same direction in your photographs. If you can't do that, at least recognize it and compensate for it in the painting.

- ⊚ Remember that the photo is only a beginning, so you do not have to paint everything in it. Do not be bound by one picture. You can pick and choose from many different photos. Just be sure that the lighting and direction of each element you use is compatible with what's going on in your own painting.

Paint *with* Passion

Reference photos are only the beginning of the amazing journey of composing a painting. If you keep this fact in mind, you'll soon realize that using your imagination to expand upon what was captured in the photo can open up whole new worlds. The painting below is an example of one of my amazing journeys.

The photo and the section from the painting have a lot in common. They both say sunflower, mainly because of shape. The painting is an emotional reaction, a conviction, a comment, a connection and a personal statement. You do not have to be bound by physical truth! Long ago my portrait instructor said that too many good portraits have been ruined by trying to get a likeness. If you set out to paint a correct painting of something in nature, do it. But realize that there are other ways to paint and references to use. You can be bound only by the truth and reality of what you want your own painting to convey. This is one time that it's all right to mess with Mother Nature.

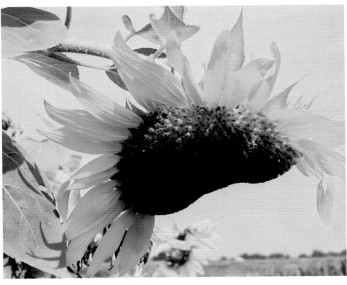

Reference Reality
Here is the reference photo I used as the basis for my sunflower painting.

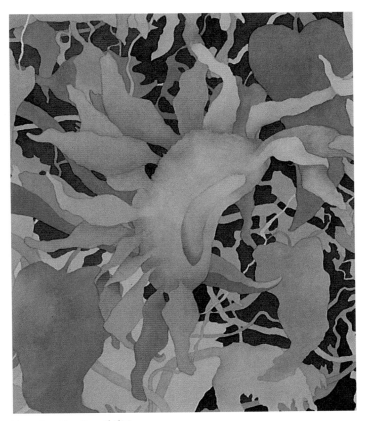

Imagine the Possibilities
This is what happened when I let my imagination run wild! Just because you have the image in front of you does not mean that the look of your painting is carved in stone. Experiment and be as creative as you want to! Don't get locked into only one mind-set.

painting LEAVES

My house is surrounded by woods, and my side yard is a state park. It's a good thing that I love leaves and trees because they are everywhere around me! They are the first harbingers of spring with that special glow of breaking buds. The redbud seems neon red-purple against the new green of spring. In the summer, hot days are cool under their tent of shade. In the autumn, my favorite time of year, the climax of their mature beauty is hauntingly bittersweet. Even in the winter, the bare branches of the trees make beautiful dark patterns against the snow or become shining crystal after the ice, always promising the return of life. That is why I have found such joy in painting leaves, just leaves...but, oh, how beautiful they are!

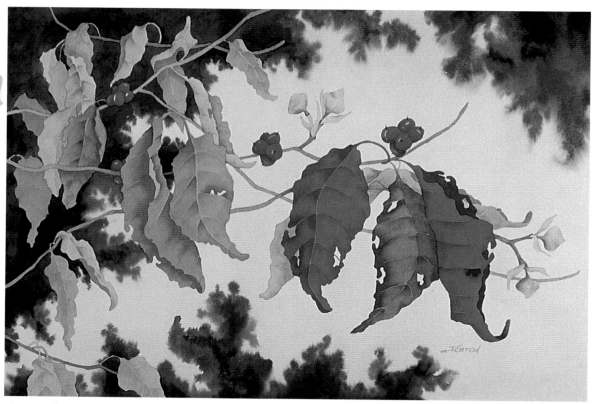

Capture the Beauty of Life in Your Paintings
When the dogwood is at the peak of its beauty, it's transferring all of its
life force to the creation of buds for the next life.

IN THE ENDING LIES THE BEGINNING • 15" × 22" (38cm × 56cm)

Yellow *and* Blue Make Green

To paint those beautiful leaves, first you need to experiment with mixing greens. Take another look at the color wheel on page 17. Remember that it is divided into three segments and that mixing colors within a segment results in bright, clear color and that mixing colors that cross the line results in grayer or less intense color. The first mixing chart illustrates this point.

As you can see, you really don't need green to mix green. You just need blue and yellow, but adding greens allows a wider variety of shades to choose from. The second mixing chart shows some of the many ways you can mix greens. In two places I added a third color toward the bottom of the mix. These colors grayed the mix, lowering its intensity. One of the darkest greens comes from Hooker's Green, French Ultramarine Blue and Sepia. Practice mixing your own green color chart. It's quick, easy and you will learn a lot about how to make the greens that please you.

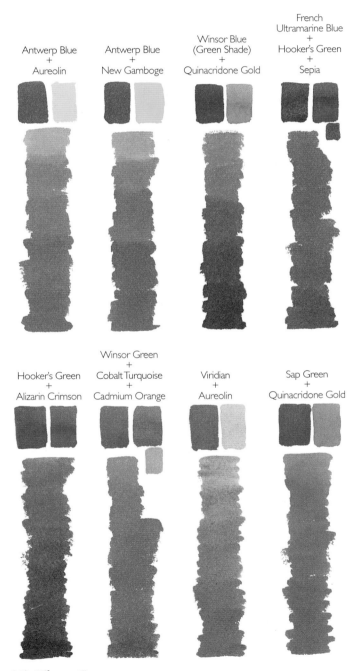

Bright and Dull Greens

In each mixture, the first line shows a little blue added to the mix and then more is added in each line. In chart *A* the colors are from the same section of the color wheel and the green is bright and clear. In charts *B* and *C* I crossed one line of the color wheel and the green is a bit grayer and less intense. In chart *D* I crossed two lines and the resulting greens are very dull and quite olive.

Mix Vibrant Greens

I have placed the colors I used in the mixture at the top of the row. Begin your mixture with the lighter color as the base and mix in a little of the darker color. Then you can add more and more of the darker color.

Create *the* Veins

There are several ways to make veins in leaves. In the illustration, all five leaves were made with the same two colors, Antwerp Blue and Quinacridone Gold. You can intensify the value change and the excitement by adding more colors, but for now I wanted you to see the variety you could get with just one color combination just by varying the amount of blue you add to the yellow. For all of these illustrations, make a puddle of Quinacridone Gold and add just enough Antwerp Blue to make a fairly light green, coat the leaf with this light base color and let it dry. For the darker green, add more Antwerp Blue to the mixture.

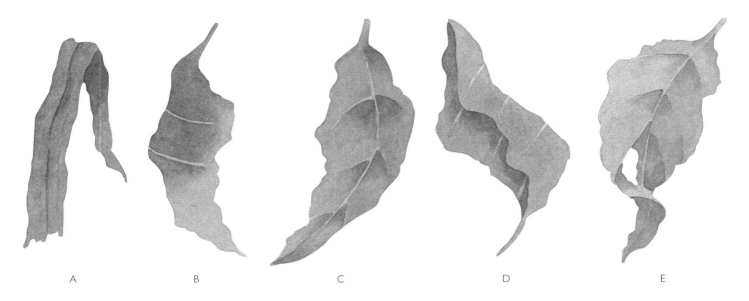

A B C D E

Create Vein Variety

Depending on your view of the leaf, veins can look very different. Try creating each of these five examples to help you gain a better understanding of leaves.

A. Add a little more Antwerp Blue to the mix and paint a dark vein using a small brush. Miss a few spots and allow the viewer's eye to complete the vein and participate in the painting. You can paint the vein thicker in a place or two, and soften the outside edge, creating the appearance of a shadow.

B. Paint around the veins with the dark green, leaving the veins light.

C. Establish the veins using a darker color to paint around the part of the vein, which might be shadowed, and then soften the color at the edge with clear water.

D. Paint the dark green on the inside of the leaf to show the two sides and dry. Wash out the veins by scrubbing them with a soft brush and clear water and blotting.

E. Draw the vein lines softly with pencil. Paint the shadow areas with clear water—enough water to moisten the area but not leave a puddle—and then load the darker color on the brush and touch it to the top of the clear water. If the darker color goes to the edge of the wet spot and begins to form a new hard edge, just soften the edge again with clear water.

Long Leaves

First try painting a long leaf. This is from a daylily, but many long leaves share similar characteristics. Then try painting a curved leaf.

[MATERIALS LIST]
- Antwerp Blue
- Burnt Sienna
- Dioxazine Purple or Permanent Alizarin Crimson mixed with French Ultramarine Blue
- New Gamboge
- Quinacridone Gold
- Winsor Blue (Green Shade)
- Winsor Red
- Nos. 4 and 6 round brushes
- Arches 140-lb. (300gsm) cold-pressed paper

Tip Always use the largest brush you can. I painted these leaves with a no. 4 or no. 6 round. If you paint them big enough to fill the whole page, you might use a no. 10 or no. 12 round brush.

1 | Cover Your Bases
Base the top portion of the leaf in a medium value of green mixed from Winsor Blue (Green Shade) and Quinacridone Gold. Let it dry. Add a little water to the mix and paint the underside of the leaf, softening the edge with water before you reach the very end of the leaf. Dry.

2 | You're in the Right Vein
For the top side, paint on part of the dark vein with your original mix. Run a damp, clean brush along the right side of the vein to fade it as if it were shadowed. Finish the vein. Indicate the softer veins, which run the length of the leaf, with a few thin lines of a darker color. For the underside, lighten the green mix with a little water and add some Burnt Sienna to make a dark khaki color. Paint the underside, leaving the vein the lighter, original color. Also soften your khaki color and don't paint it into any places where you might want to put a highlight. Use Burnt Sienna fairly dark to complete the end of the leaf.

3 | A Hole in One
On the upper part of the leaf, add some sunlight using a thin glaze of Quinacridone Gold and soften the edges. Deepen the color of the vein if needed. You can also add some touches of Burnt Sienna in places and soften the edges. You can even make a bug hole by painting Burnt Sienna around an imaginary hole and softening the outside edges. For the underside, darken the khaki mix with Quinacridone Gold and shade the upper part—still painting around the vein. Also, shade around the place where the vein curls below. If your paint is still not dark enough, add a touch of Winsor Blue (Green Shade) and Burnt Sienna to it. There! You have your first leaf.

Curved Leaves

Here you will learn how to paint curved leaves. These usually follow a gentle turn, and their center veins have many branches. These vary from the long leaves you just painted, because long leaves usually turn rather abruptly and their veins are rather straight, extending from top to bottom.

[MATERIALS LIST]

- Antwerp Blue
- Dioxazine Purple or Permanent Alizarin Crimson mixed with French Ultramarine Blue
- New Gamboge
- Quinacridone Gold
- Winsor Red
- Nos. 6 and 8 round brushes
- Arches 140-lb. (300gsm) cold-pressed paper

1 Get the Basics Down
Base the leaf in a light green mixture of Antwerp Blue and Quinacridone Gold, and let dry. Just establish the basic form and give yourself something to work with. Use a medium-size round brush, such as a no.6 or no. 8 round. A light mix gives a nice underglow and is also easy to paint over or change.

2 Shade the Veins
Using the same mixture—add a bit of water if it has dried too much or seems much darker—shade the inside section, establishing the veins by painting around them with a no. 6 round. Don't do the whole vein, just the main parts and soften the edges with water. Also shade the vein areas on the top of the leaf. Let dry. If it isn't dark enough to suit you, you can glaze the whole thing with a thin mix of the original color and let it dry again.

Add a Touch of Excitement

3 | This is all about adding excitement using touches of color! Use thin glazes and soften the edges to add color wherever it seems appropriate. Place Dioxazine Purple in the darker areas and touches of very pale Winsor Red and New Gamboge. If you need a darker color in the darkest spots, you can use Dioxazine Purple and Antwerp Blue in a little heavier mixture than a glaze. Don't forget to keep the edges soft. You can glaze the whole leaf again if the color is not right. You can make it more green with a very thin glaze of Antwerp Blue or less green with a glaze of the complement, Winsor Red. These glazes must be very pale and watery or the leaf will change color too much.

Set the Tone

This is the same leaf drawing, but I added more Antwerp Blue to it and that affected the total color impact. Your base coat can set the color tones for the whole leaf, so choose it carefully.

Set Off Your Edges with Dark Backgrounds

Painting a dark background with both hard and soft edges will set off a vibrant or light-colored center of interest. It's also a good way to add interest and depth to the composition by making the negative space more exciting.

Since you must keep the edges of the dark paint wet, you need to include lines in the drawing to give yourself places to stop. Think about where to change colors before you paint. If one edge is drying too quickly while you work on another, wet it with water, eliminating any hard lines. Let dry, re-wet and repaint later. This technique sounds complicated, but it's really quite simple and forgiving.

Think about how the color flows as you paint. It's very important to continue a particular color as it goes under the stem, vine or leaf.

The more often you begin a color change on one side of a shape and continue it to the other side, the more unified and interesting your background will be. Try to have lots of color variety in paint edges. You can re-wet any edges that don't satisfy you and paint them again. A touch of another color along the soft edge adds to the excitement, and you can always add this by simply re-wetting.

In this demonstration you will learn how to soften an edge, how to change colors and several ways to "fix" areas that don't turn out so well. Do not be afraid to experiment with fixing. Watercolor is forgiving. Only after you have learned a lot about fixing do you start to become comfortable with painting.

[MATERIALS LIST]
- French Ultramarine Blue
- Hooker's Green
- Permanent Alizarin Crimson
- Sepia
- Four medium-sized brushes—any size, nos. 8 to 10
- Arches 140-lb. (300gsm) cold-pressed watercolor paper

Tip Use a separate brush for every color. This will allow you to change colors quickly without rinsing your brush and reloading it all the time.

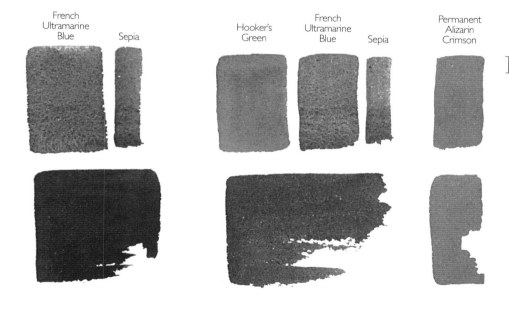

French Ultramarine Blue / Sepia / Hooker's Green / French Ultramarine Blue / Sepia / Permanent Alizarin Crimson

Background Color Combos

1 Mix three large puddles of color using a no. 8 or no. 10 round brush for each. Mix your dark navy blue puddle using French Ultramarine Blue and Sepia. The amounts are indicated in the color chart on the left. Be sure to test it first on scrap paper. Next mix the green puddle using the amounts shown on the color chart. Begin with Hooker's Green, add enough French Ultramarine Blue to make a calm green, then add a bit of Sepia to darken it. Your last puddle is easy; it's just pure Permanent Alizarin Crimson.

2 **Practice Your Hard and Soft Edges**
Draw the leaf shape at your center of
interest, then draw a vine line from
the leaf to the left edge so that you will
have a stopping place for your wet
background. Position the vine so that
it encloses the space you are painting
and there is only one wet edge to
worry about.

Begin in the corner with your blue
mix and continually move down
toward the vine and over toward the
stem and leaf.

Create a soft edge underneath the
vine on the left side by wetting the
paper a little below the vine and paint-
ing from the vine into the wet areas.
Reload your brush after each time that
you paint into the wet edge. Be sure
to paint randomly into the wet area
so that your final edge is varied and
exciting.

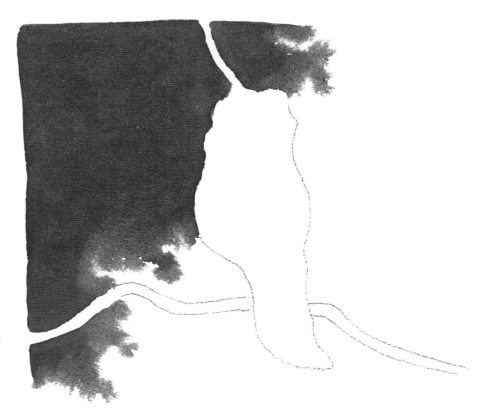

TIPS FOR PAINTING A DARK
BACKGROUND

- ◉ Prop your support board approximately an inch (two centime-
 ters) higher at the top, so that your paint will always flow toward
 the bottom of the paper.

- ◉ Begin painting in the upper left corner if you are right handed
 and vice versa.

- ◉ Stroke in different directions to keep the paint edges wet.
 Stroking the watercolor in only one direction will cause lines
 once it's dry.

- ◉ If you don't get a soft edge, then your paper is too dry. Allow it to
 dry completely. Re-wet below the previous edge and re-wet the
 painted area above the problem edge. Then paint from wet to
 wet again to create a new edge.

- ◉ Only paint into an area that is still wet. You can tell if the paint is
 drying because it will begin to lose its shine. Once the paint
 begins to dry, wash the edge with clear water to soften it, and let
 it dry completely. Then re-wet and resume painting.

3 | **Beef up Your Background**
Redraw your leaf, stem and vine
shapes for your final painting. Be sure
you have plenty of paint in your pud-
dles. Start at the upper-left corner with
blue, leaving a random edge, and then
use the brush loaded with green to
paint directly into the blue while it is
wet. This will make the colors flow
nicely from blue to green. They will
mix better if you have about the same
amount of water in each color and
keep the support slightly propped.
Continue painting with green to the
stem edge.

You can add Permanent Alizarin
Crimson at any time while the paint is
still wet by loading the third brush with
red, blotting it to remove the excess
water, and painting into either of the
other colors. Use the red to call atten-
tion to an area, but don't go too close to
the edges of the painting.

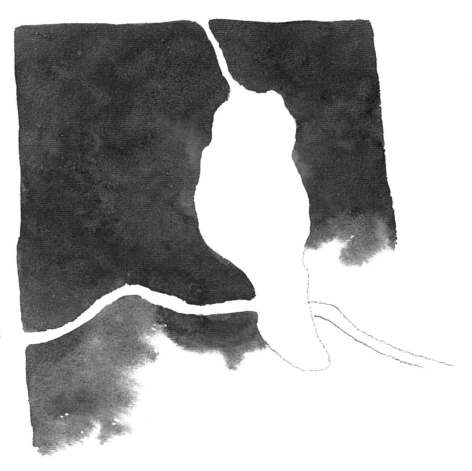

TROUBLESHOOTING FOR DARK BACKGROUNDS

Problem	Solution
◉ Too much pigment in one area	◉ Lightly dab with a wet brush to move the pigment to the side
◉ Area is too dark and uninteresting	◉ Softly scrub, blot and repaint with red
◉ Edges are too hard, wrong color or shape	◉ Re-wet, add more edges and soften again
◉ Area is not dark enough	◉ Re-wet above and below, and add another layer of the same color

Tip Color change in the negative space is especially
effective if you run the change underneath a leaf or vine. That
puts the background truly behind the positive spaces. Using
color change in the soft edges and using a variety of color
shapes help make the edges more interesting.

Dogwood Leaves

I think the dogwood is one of the most beautiful trees ever created. Its delicate spring flowers are surpassed only by the variety of color in its spectacular autumn leaves. To me, the autumn riot of color is bittersweet, so beautiful yet so short. Even though it's the ending of one season, the buds of new life are already growing—a perfect representation of the endless circle of existence.

It's not necessary to be botanically correct in either shape or color in the demonstrations on pages 41-43 and 44-48 because you'll be employing a little creative and artistic liberty. Even though it's your own personal vision, it must approach reality, so you need to understand the shape and habits of the leaves. I recommend you study some leaves, if you can find them. Notice the broadness in the center and lower center. Look at the vein pattern and the ruffled edges. Curve them with your hand to see how the veins flow when you turn up the side or bottom.

Study and try drawing some leaves yourself. Choose a shape that interests you most and create a composition using one leaf only. Look on pages 41-43 for a step-by-step demonstration on how to create an amazing painting with only one leaf as your focus. Later on pages 44-48 you will take the lessons you learned to a higher level by trying your hand at a multiple-leaf painting demonstration.

Keep it Basic
The basic leaf shape for the following examples.

Flip a Side
Flip a side and notice how the veins follow the curve of the leaf. Be careful that the amount flipped is in proportion to the rest of the leaf. If you straightened the leaf out, would it follow the basic shape or would it be much too broad?

Flip it Even More
The flipped side will shadow the other part. Decide which side of the leaf will be darker, the front or the back. Usually in nature the front is more intense and colorful, but you may take artistic license in your composition.

Try the Other Side
This is probably unrealistic in proportion, but I think it works. You can push the envelope a bit.

Bottoms Up
Make sure the curve into the flip works and the direction is fairly realistic.

A Different Shape
Create more interest by showing both the front and the back of the leaf. Value is very important in helping the viewer to understand which side is which.

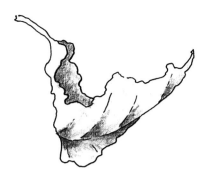

Curve the Leaf
Again, value is important. Also, shading on the curve gives the leaf form.

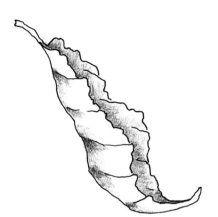

Another Curve
Note the variety in value on the inside section. It is darkest where it would be shadowed by the outside curved section and lightest as light catches the outside section.

Shadow Secrets
Pay special attention to the darkest sections that make the form happen. The inside shadowed area would probably be uniformly dark, but creating a lighter place in the middle makes it much more interesting.

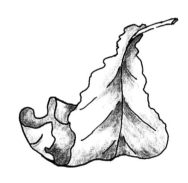

Bug Holes
This leaf has a variety of shadows in the inside area, but its real interest is the bug hole. These holes can be anywhere and any shape, but often they follow part of a vein. The edges of a hole usually turn darker and are very irregular if not beside the vein.

Value Variety
You can flip the bottom of the leaf and get wonderful variety by using light against dark and dark against light.

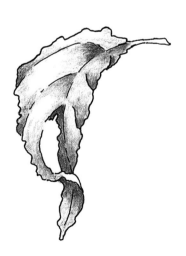

Beautiful Buds
The buds for next year's flowers are a wonderful shape, which you can turn in every direction, and the bright red berries add punch wherever you need it. Notice how one section of branch grows out of another.

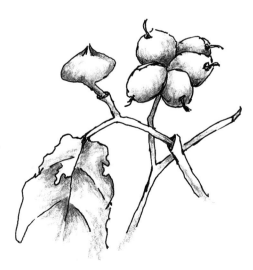

The Magical Dogwood

Sometimes leaves are unbelievably complex in their mixture of colors. When I got back three rolls of film that I had taken of fall dogwood leaves, I was amazed at the myriad colors in them. The photos gave me the license to invent, which I had been looking for. After that, all my paintings became a very personal statement, combining reality and fancy and allowing me to paint not only what I see but also what I feel. Dare to put your own personality into every painting. Your unique view is the most important quality that you have to offer to your art!

[MATERIALS LIST]

- French Ultramarine Blue
- Hooker's Green
- New Gamboge
- Permanent Alizarin Crimson
- Sepia
- Winsor Red
- Winsor Violet
- Four medium-sized round brushes—any size, nos. 8 to 10
- Three round brushes—nos. 4 to 6
- Arches 140-lb. (300gsm) cold-pressed watercolor paper

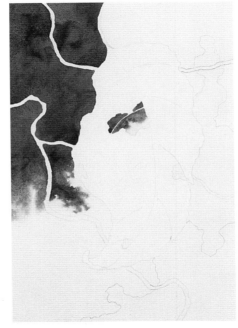

Tip Complete the getting-ready step before you begin any painting. You'll need to stretch or tape your paper to a support, wash the paper gently with a sponge and let it dry, work out your composition on tracing paper, transfer the composition to the watercolor paper with wax-free transfer paper and mask any white areas if needed.

1 | **Create the Composition**
Draw the basic leaf shape (refer to pages 39-40). Decide where the dark background will stop and indicate it with a smudgy pencil line. Make some vine shapes, which flow through both the dark and the light background, so you can control the wet edge. Create some interesting openings (e.g. bug holes) in the leaf, especially some that will allow you to see both the dark and the light background through the hole.

2 | **Lay the Foundation**
Cover all the light background area with a very thin and watery wash of New Gamboge. Use just enough to tint the paper a creamy color. Allow this to dry. Mix large puddles of blue, green, and Permanent Alizarin Crimson—as described in the mixing chart on page 36—using a separate brush for each color. Lay in the dark background with a medium-size round brush. When you have used half a puddle, remix and the colors will match well enough. Remember to wet the paper before you paint a soft edge into an area.

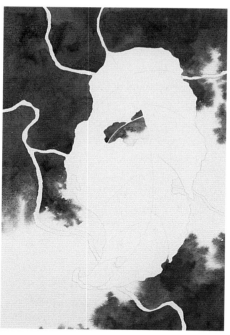

3 | Make it Flow

Continue building the background with your three puddles of color. Be sure to make one background color flow underneath each positive shape. Use the red to brighten areas.

Tip Use a large and a smaller round brush for tight spots for each color so you will be able to do the whole background without rinsing a brush. Saving that time will let you pay more attention to keeping the wet edge wet.

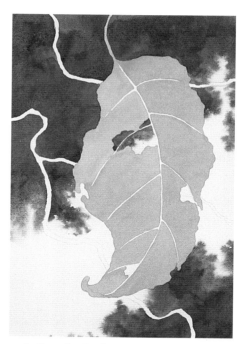

4 | Base the Leaf

Use a very pale, watery wash of Winsor Red to create the leaf. Paint around the veins, leaving the white of the paper. This will establish the veins but is light enough to allow for changing any goofs!

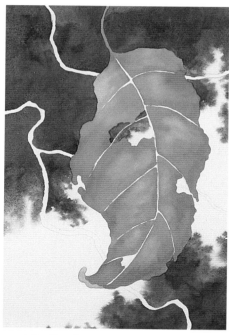

5 | Reality Check

Think how the sun would hit the leaf or how the bending of the leaf would cause lighter or shadowed places, and decide where the highlights and the darker areas will be. Lay in New Gamboge in the highlighted areas and soften the edges. Paint a mixture of Permanent Alizarin Crimson + Winsor Violet in the shadowed areas and soften the edges. Allow the paint to dry. For a transition between the light and shadow, use a mixture of Winsor Red + a bit of Permanent Alizarin Crimson and soften the edges. This will be the local color of the leaf.

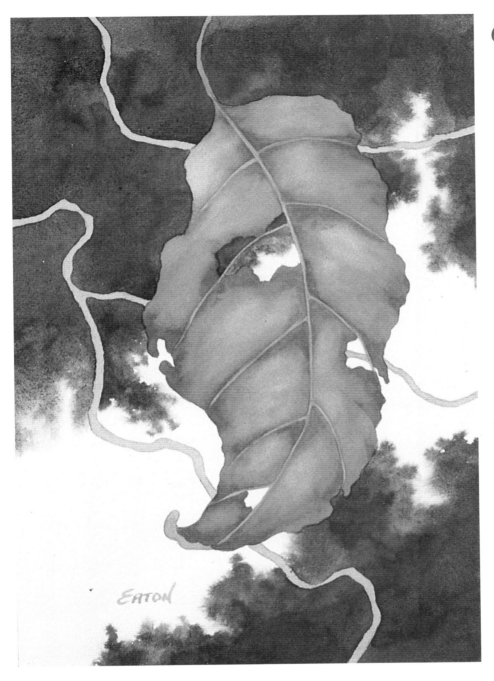

Final Touches

6 | Make a fairly light mixture of French Ultramarine Blue + a bit of Sepia and shade the darker areas of the leaf. Reapply as needed. These colors make a rather opaque mix, but the edge softens easily; the colors move well and are quite correctable. Use this mix to darken areas around veins, bug holes and any shadowed areas. Paint the white veins with a thin wash of Winsor Red and Permanent Alizarin Crimson. Soften any area that you overlap onto the leaf itself with a damp brush. Dry.

If there are any areas around the veins that you don't like, scrub them lightly with a hard bristle brush and blot. You can also do this if the veins don't show enough now. Now it's time to sign your name if you like the painting. If you don't like the painting, sign someone else's name, but make it up.

A TOUCH OF FALL • 6" × 5" (15cm × 13cm)

43

Several Dogwood Leaves

Now that you have mastered the basic leaf shapes, you are ready to create a more complex composition. Use tracing paper for your first drawing because it may be involved enough to require some erasing. Consider the lessons on composition before you jump right into your initial drawing.

In my drawing, the main leaves are to the right of center and below it. I wanted to lead the eye in from the upper left corner, so I added leaves there and continued moving toward the center of interest. As the leaves got closer to the center, they also became closer in size to the main leaves. Remember, though, that there is only one star in a painting. Therefore, the three leaves in the center of interest will dominate the painting by having the largest size, the most color impact, the most interesting value change and the most detail.

You must also take into consideration how the branches will lead the viewer's eye through the painting. Knowing that the top left corner was going to be dark background, I arranged branches to break up that space so I would have smaller areas of dark to do at a time and some easy stopping places for the wet edges.

Draw the boundaries of the dark background with wiggly lines to distinguish it from the drawing itself. Make the dark background flow behind some positive shapes, and leave exit space for the light area to go off the page. Don't enclose the whole painting with dark.

[MATERIALS LIST]

- Burnt Sienna
- Burnt Umber
- French Ultramarine Blue
- Hooker's Green
- New Gamboge
- Permanent Alizarin Crimson
- Sepia
- Winsor Red
- Three medium-sized brushes—nos. 8 to 10 (use for the larger areas)
- Two small round brushes—nos. 4 to 6 (use for the detail areas)
- 1-inch (25mm) flat brush
- Half sheet of Arches 140-lb. (300gsm) cold-pressed watercolor paper
- Other supplies from page 11

Tip Paint a thick line of both the blue and green mixes on a piece of watercolor paper and tape it beside your painting. This will help you remix a similar color using the test paper as your guide.

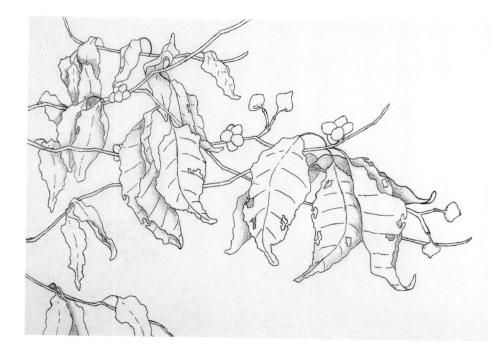

1 Prepare to Paint
Complete the getting-ready step (see page 12). Be sure to check back on pages 39-40 if you need help with any of the shapes of the dogwood leaves. When you are finished, check your drawing carefully to be sure that it is all there and that you can tell the positive leaf and branch shapes from the lines that mark the end of your dark background or negative shapes.

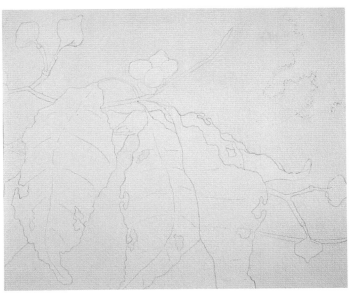

Tone the Light Areas

2 | Mix New Gamboge and a lot of water to get a creamy, transparent yellow and paint all of the light, negative spaces with a 1-inch (25mm) flat brush. Don't worry about being perfect! The dark top layer will cover any mistakes. Eliminate any hard lines by softening them with water. After this has dried completely, go back to any places that are too light and add a little more watery yellow and soften the edges so the background is uniform. Toning with this yellow makes the painting seem filled with sunlight, and it will help you distinguish edges when you are painting the positive shapes.

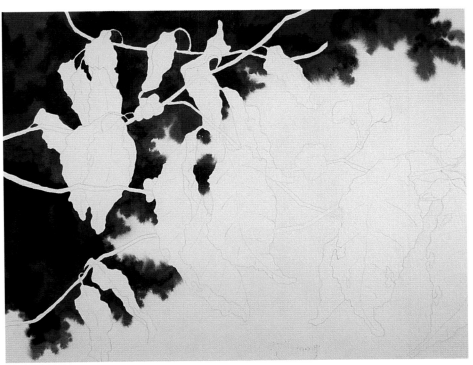

Begin the Background

3 | Mix the three background colors—red, blue, and green—as described on page 36. Before you start an area, think about the negative space and where it ends so you don't paint the wrong area. Start in an easy, relatively small place that has no soft edges. You'll be able to get the hang of what your colors will do and how they are going to blend. Keep a wet edge. As you change colors, go back into wet paint with the new color. You can add red anywhere that needs a touch of excitement. Red blends well, so it can go over another color, under it, or onto white paper and then be painted over. Check to see that the color shapes are asymmetrical, with no rectangles, circles or squares. Make the edges irregular and vary the sizes of the color shapes.

Tip Be sure to mix large puddles before you start and to mix more paint into each puddle when you have used about one-fourth of it so that the color will stay very much the same throughout the painting. Frequently stir the puddles so the color mixture doesn't separate.

Work it Out

4 You are now ready to work out your color scheme for the leaves. Paint each one of them with only a light wash of color in case you want to change it. Leave white veins only on the larger leaves.

Reserve the most intense colors for the leaves in the center of interest. Paint the rest of them with colors that contrast but harmonize with adjacent leaves.

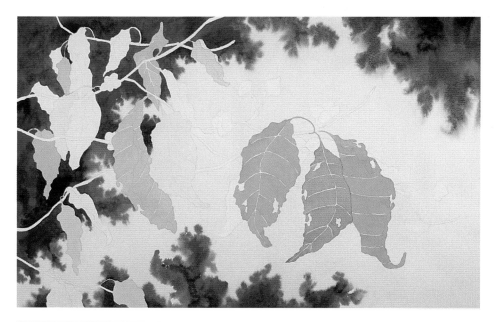

Bring Up the Color

5 It's time to make your colors more intense! On the large, red leaf in the middle, add a glaze of Permanent Alizarin Crimson. Glaze Winsor Red on the large, red leaf on the right side. Glaze the peach leaf with Burnt Sienna and Winsor Red. Use the original color and its complement or the original color mixed with a darker color to darken any leaf. For example, on the pink leaf toward the top, I darkened the underside with Winsor Red and a touch of French Ultramarine Blue. On the sandy leaves I added Burnt Umber to the original color. The blue leaves can be made darker on one side by drying them and going over the shadowed area again with the same color. Experiment on a test-strip paper. It's also fun to add a touch of color from the neighboring leaf as if the color were being reflected.

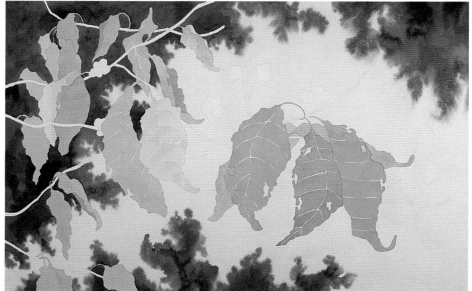

SHORTCUT TO COLOR

Yellow leaves–New Gamboge

Red leaves–Winsor Red

Peach leaves–Winsor Red + New Gamboge

Sandy leaves–New Gamboge + Burnt Umber

Olive leaves–Green background mix + Burnt Sienna

Rusty leaves–Burnt Sienna + Permanent Alizarin Crimson

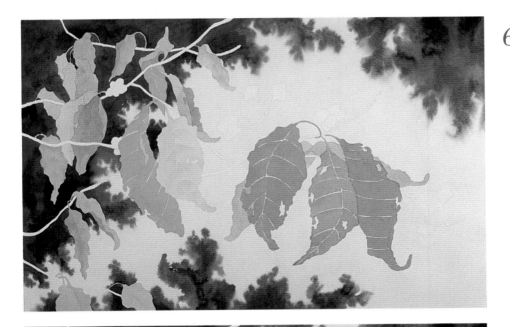

Deepen the Hues

6 Repeat glazing on any leaves that need to be more intense. Add colors in rather thin layers and allow each layer to dry; this will keep the painting rather transparent but still give you more intense color. Adding too much pigment at one time may make the color opaque and sometimes rather muddy. Remember, the leaves in the center of interest need to have the most intense color and most glazes. After two coats of color, you can paint right over the white veins and they will still show. Add color to the five central leaves, but leave the blue and light brown leaves in the background rather muted to keep them from competing with the stars of the painting. Wash the green leaf with Hooker's Green + French Ultramarine Blue + Sepia on its shaded side.

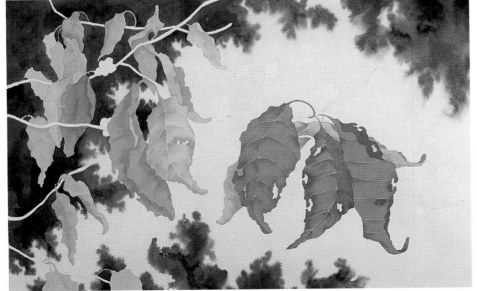

Define the Form

7 You can make darker areas on the leaves to define shadows, bug-hole areas or a part of the leaf that is turning away from the light. Get a darker value by simply mixing more color into the original puddle or by using a contrasting color. On the right red leaf, use Sepia + Winsor Red + French Ultramarine Blue for the dark. On the middle red leaf, use French Ultramarine Blue + Sepia. On the large green leaf, just use a darker mixture of the green. Shade the peach leaf with French Ultramarine Blue + Burnt Sienna. Shadow the larger, yellow leaf with New Gamboge + Burnt Umber.

8 | Paint the Buds and Berries

Paint the branches and stems with a dark gray mix from French Ultramarine + Sepia and a puddle of fairly strong Burnt Sienna. Water down the gray mix even more to create a light green color. Paint with the Burnt Sienna and add the gray wet-in-wet along the bottoms and forks of the branches.

Paint all berries a medium red (Winsor Red + Permanent Alizarin Crimson), leaving a white highlight on some. Redraw the lines around the berries and shadow the areas furthest back with a mix of Winsor Red + Sepia. Make the berry points with a bit of Sepia.

Create three mixtures for the buds: French Ultramarine Blue + Sepia (blue-gray), French Ultramarine Blue + Permanent Alizarin Crimson (purple-gray) and a very light puddle of Permanent Alizarin Crimson. Paint the bud purple-gray. While it's wet, paint the base blue-gray and touch the top lightly with Permanent Alizarin Crimson. Touch the blue-gray to the stem and round the bottom with a shadow. Use the same three colors for the bud leaves. Go light at first and reserve the blue-gray to help you add definition.

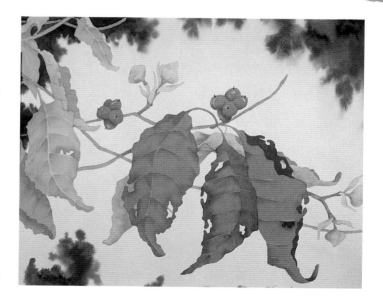

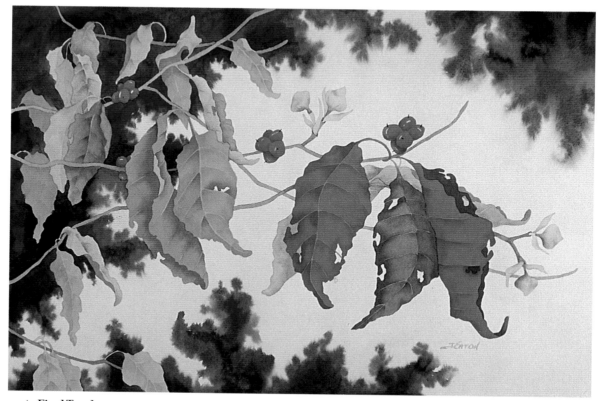

9 | Final Touches

You might want to touch the berry highlights with New Gamboge so they are more subtle. Look for any places that still need stronger color or more contrast. Sign your name. Congratulations, you're done!

IN THE ENDING LIES THE BEGINNING • 15" x 22" (38cm x 56cm)

Oak Leaves

Oak trees, of one kind or another, are abundant all over the world. The leaves are fascinating in their infinite variety! They contain an amazing array of colors and textures that change with the seasons. Next time you see an oak tree, lie underneath it and see what a different view you have. The sky and leaves create an amazing composition of lights and darks. Be sure to snap a picture of the leaves from any angle and see what you can come up with. A simple photo holds a colorful story. What fun for a painter to explore!

First, you need to become familiar with the oak leaf itself. Get some if you can and practice drawing them. If you can't find any lying around, try an art-and-craft supply store. Odds are that they will have some artificial leaves you can use for close inspection.

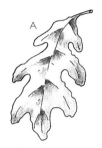 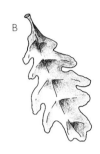

Leaf Lessons

A. This is the basic oak leaf shape.

B. There are so many different varieties of oaks that leaves may have three or four side wings, and sometimes they are very asymmetrical. What a joy for us painters!

C This leaf twists one way and then another. It also has bug holes.

D. Another kind of twist.

E. This one is curling in.

F. This one is curling and viewed from the back.

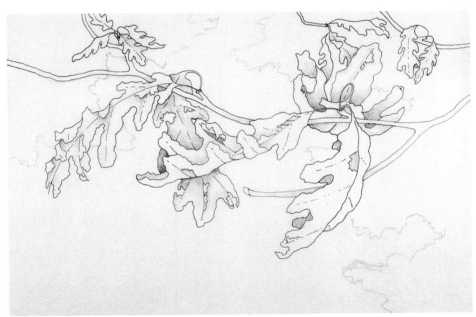

Create Your Composition

Try to create a composition on your own using some of the leaves from above. The main points to remember are to: determine the center of interest and start with the main leaves, overlap and use a variety of leaf shapes, and use branches and smaller leaves to guide the eye around the painting.

This composition will be used in the demonstration on pages on 50-52, which will include another dark background. Decide what areas will be dark and make sure that you have branches, vines or leaves to give you a stopping point in areas that are too big to be comfortable for you. When you are happy with your composition, transfer it to your paper.

Oak Leaves

Now that you are familiar with the basic composition of oak leaves, it's time to turn your knowledge into a powerful and beautiful painting. You will be using many of the same steps as in the dogwood leaves demonstration on pages 41-48. Refer back as necessary or add your own twist to this painting.

SHORTCUT TO COLOR

Green leaves—Hooker's Green + a touch of French Ultramarine Blue, Winsor Lemon and Sepia

Red leaves—Winsor Red, dry, glaze the top section again

Pink leaves—very light (thin) Winsor Red

Blue leaves—French Ultramarine Blue + Sepia

Curled leaf in upper right—inside use pale Permanent Alizarin Crimson, dry, and paint the outside either light French Ultramarine Blue or mix that with Cerulean Blue

Yellow leaves—light New Gamboge

[MATERIALS LIST]

- Burnt Sienna
- Burnt Umber
- Cerulean Blue (or substitute a light wash of French Ultramarine Blue)
- Hooker's Green
- French Ultramarine Blue
- New Gamboge
- Permanent Alizarin Crimson
- Sepia
- Winsor Lemon
- Winsor Red
- Winsor Violet (or substitute French Ultramarine Blue + Permanent Alizarin Crimson)
- Yellow Ochre (or substitute a light wash of New Gamboge + a touch of Sepia)
- Three round brushes—nos. 8 and 10 (one for each background color)
- Two small round brushes—nos. 4 and 6 (use for the detail areas)
- 1-inch (25mm) flat brush
- Arches 140-lb. (300gsm) cold-pressed watercolor paper
- Other supplies listed on page 11

1 Begin the Background

Transfer the composition from page 49 and use your 1-inch (25mm) flat to tone the negative space with New Gamboge. Let dry. Next, do the dark background, just as you did in the dogwood painting on page 41. Use the same colors, each with a different brush. Remember to start in the upper left if you are right handed. Be sure you understand where your stopping place is and where you are going to soften with clear water before you begin an area. Try to plan a flow of color underneath the positive shapes.

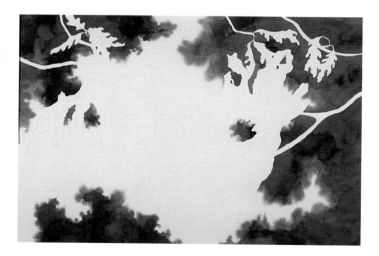

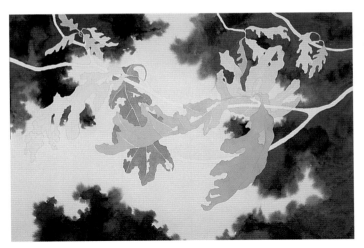

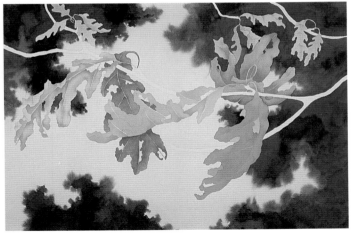

Base the Leaves

2 | Work out your color scheme for the leaves and don't forget to paint around the veins of the central leaves for the first few glazes. After that, you can paint right over the veins and they will still show up. Choose the largest or smallest size round you feel comfortable working with in the various areas.

Tip If you get a harsh dark line by the vein, just soften it with water. Also, you can enhance the shading on any smaller leaves with the same colors you used in step four.

Here Comes the Color

3 | Glaze the top, blue leaf with French Ultramarine Blue + a touch of Cerulean Blue and Permanent Alizarin Crimson, then shade the bottom section of the pink areas with French Ultramarine Blue + a bit of Sepia. Deepen the shading on the pink areas with Permanent Alizarin Crimson and French Ultramarine Blue. If necessary, give the yellow leaf another glaze of New Gamboge and shade it with New Gamboge and Burnt Sienna. Add some light Winsor Red to the darkest areas. Create red reflections on the green leaf—and anywhere else—with Winsor Red. Paint the smaller yellow leaves with a lighter shade of New Gamboge and shade with Burnt Umber. Intensify the right, red leaf with a glaze of Winsor Red and paint New Gamboge highlights right into the wet red. Where the leaf curls or gets dark, use Permanent Alizarin Crimson and the French Ultramarine Blue mix. Don't paint the underside. Alternate between large and small round brushes as needed.

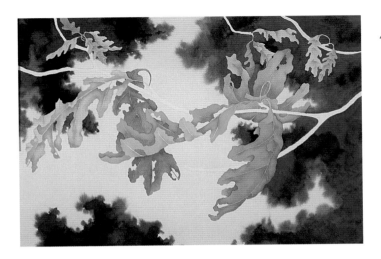

Glaze the Leaves

4 | Mix a puddle of French Ultramarine Blue with a bit of Sepia until you have a light gray. Glaze the red leaf again, if needed, and shade the section underneath with the gray mix. Glaze the pink leaf, if needed, and shade with the gray. Glaze the yellow leaf and enhance the shading with Winsor Red. Use your green mix with a little water to paint the white veins on the green leaf.

Evaluate the background edges and complete as necessary. You can re-wet your dark mixes and use them again by painting into the darks with water, then applying a new dark mix and creating a new soft edge. I corrected a little wing that had formed to the left of the blue and lavender leaf.

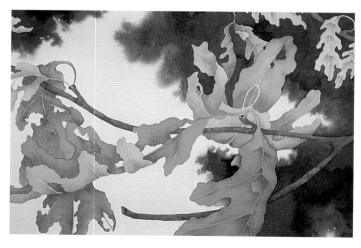

5 | Check the Contrast

On the red leaf, the blue wasn't giving enough contrast, so I glazed the darkest shaded spots on the inside with Winsor Violet + French Ultramarine Blue. I also shaded the entire leaf more with gray. To paint the branches, mix a puddle of dark gray from French Ultramarine Blue + Burnt Sienna. Paint with the Burnt Sienna and add the gray mix wet in wet along the bottoms and forks of the branches.

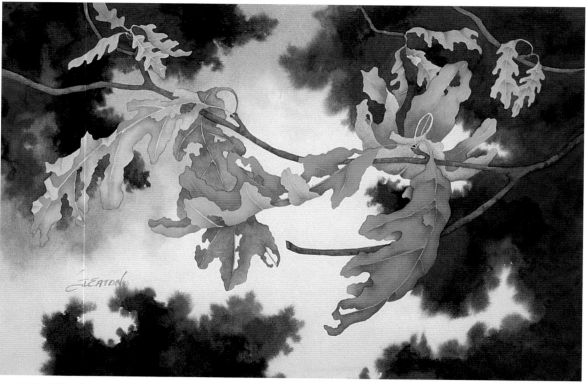

6 | Final Touches

See if anything needs another glaze of color or more shading for contrast. You might need to enlarge your background anywhere, especially around the yellow leaf. Try adding some of the gray mix over the light background to give more depth and to create a cool area for better contrast around the warm yellow leaf. You're done. Enjoy!

LAST FLING • 15" × 22" (38cm × 56cm)

Grapes *and* Leaves

One day I was walking down the street and saw these beautiful grapes sprawling across a fence. The light hitting them made them sparkle! I snapped the last shot left in my camera. Unfortunately, the shot was a disappointment when the film came back. The photo didn't capture the beautiful light or the great colors, but it did show the leaves in all sorts of shapes and directions, the mass of grapes and the old, dead leaves. The photo turned out to be a blessing in disguise because it made me use my own creativity and go beyond being bound to the reference material. I found a lot of composition ideas in that one picture. It also showed me how much you can get from only one photo and how much can be personal interpretation. In the end, I also set up some grapes from the grocery and a grape vine with leaves from a nursery in my studio for reference.

Reference Photos

Here are a few wise words from one painter to another: Take every chance you can get to snap that one great reference photo! I had only one truly clear reference photo for this grapes-and-leaves painting, which quickly became a prize possession for me. Depending on where you live and what grows in your area, you may not have images readily on hand when you want to paint them. Keep a close watch when you travel; sometimes traveling can provide interesting painting opportunities. Thankfully, one of my students, Sandy Butterworth, decided to share one of her photos for this book (at right).

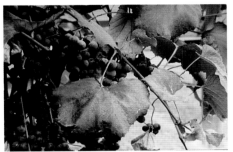
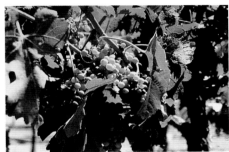

Tip Always get familiar with your subject before you draw it. The grape leaf is basically heart-shaped with bites out of each side. The front is usually dark and the back light. Mature leaves are big, but there are many tiny leaves, vines and woody stems.

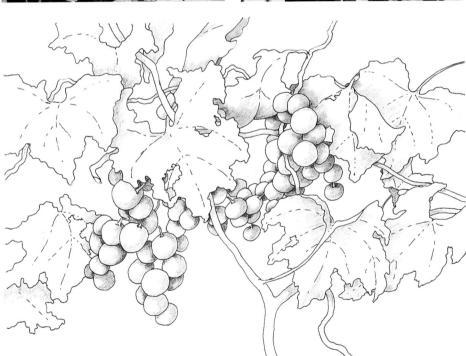

Rough Out the Road map

Try your hand again at creating your composition. Remember to overlap leaves, use a variety of leaf shapes, have the positive shapes go off the page in several different places, mass the grapes and use some woody stems and some curving vines.

You can see my drawing above, which will be used in the demonstration on pages 55-59. I would recommend again that you use transfer paper and reserve your original drawing as a road map for easy reference during the demonstration.

Grapes

Before you jump into the complete grapes-and-leaves step-by-step demonstration, take time out to practice your grapes. This mini demonstration will show you some special techniques to make your grapes look realistic by leaving highlights and adding roundness and texture.

Tip Try a variety of color combinations on a test strip before you begin painting the grapes. This is a good lesson in color mixing and will really get your creative juices flowing.

[MATERIALS LIST]

- Permanent Alizarin Crimson
- Burnt Sienna
- Cadmium Orange
- Dioxazine Purple
- French Ultramarine Blue
- Quinacridone Gold
- Sepia
- Winsor Blue (Red Shade)
- Winsor Red
- Winsor Violet
- Nos. 4 to 10 round brushes (use the no. 4 for the details and the larger brushes as necessary)

1 | The First Wash

You can paint the first wash of color with one color or drop in another wet in wet. Use any of combination of the colors listed above. Leave a white highlight with either a soft or hard edge using a no. 4 round. If the edge is to be soft, leave a large white space, soften with water and daub with paper towel or cotton swab if the color creeps too far and you begin to lose the white. Use darker or cooler colors for grapes at the back of the bunch. Don't be afraid to use unrealistic color! You've got that artistic license.

2 | Round Out the Darks

Round the grapes by adding deeper color (the same or a different mix) to the sides. Make adjacent grapes different enough for contrast. Define the shadowed areas with any dark color. French Ultramarine Blue + Sepia or Winsor Violet are both good for darks. Use two brushes, one for paint and one for water, so you don't have to rinse brushes all the time.

3 | Define with Texture

Add more color for roundness. Let some of the edges of your brush strokes show to add texture. Define crevice darks (little places where two shapes meet far back in the shadows) with a really dark mix and soften the edges. Add texture by loading the brush with a dark color that goes with the grape color, blotting well, holding the brush horizontally (as if drybrushing) and patting on specks of color. If your color gets too heavy or hard edged, you can smudge it with your finger or paper towel or pat it with a clean damp brush to soften the edges.

Learn to Layer with Grapes and Leaves

In this painting, you will get crazy with color on the grapes and learn a new background technique called layering. You can make it as simple or as complicated as you like. The demonstration painting has a lot of grapes. I always say the more, the merrier.

SHORTCUT TO COLOR

Green—New Gamboge + Winsor Blue (Red Shade) + touch of Permanent Rose

Darker green—French Ultramarine Blue + Hooker's Green + Sepia

Bronze—New Gamboge + Sepia

Gold—Bronze mix + Quinacridone Gold

Olive—French Ultramarine Blue + New Gamboge + Sepia

Tan—Quinacridone Gold + Sepia

Blue—Winsor Blue (Red Shade) + French Ultramarine Blue + Sepia

[MATERIALS LIST]

- Burnt Sienna
- Cadmium Orange
- Dioxazine Purple
- French Ultramarine Blue
- Hooker's Green
- New Gamboge
- Permanent Alizarin Crimson
- Permanent Rose
- Quinacridone Gold
- Sepia
- Winsor Blue (Red Shade)
- Winsor Red
- Winsor Violet
- 1-inch (25mm) flat brush and a variety of round brushes—nos. 4 to 10 (use the no. 4 for the details and the larger brushes as necessary)
- Arches 140-lb. (300gsm) cold-pressed watercolor paper
- Other supplies listed on page 11

1 | **Begin the Background**
Complete the getting-ready step (refer to page 12). I used the composition from page 53 for this demonstration. Fill in all the background with a thin wash of New Gamboge.

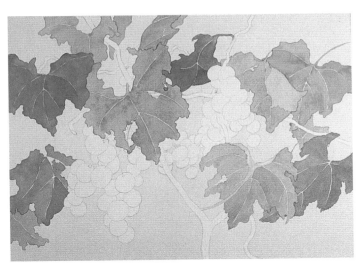

2 | **Underpaint the Leaves**
Base paint the first light color on all the leaves. Use color variety, but the grapes will be the stars, so don't go too wild. Now is the time to add any other leaves you might need.

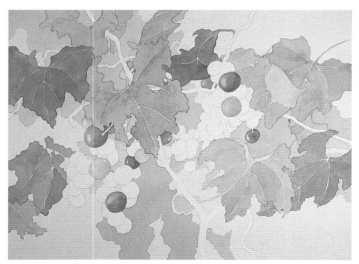

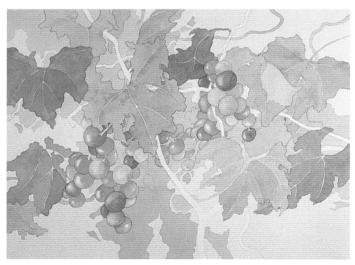

3 | Begin the Layered Background

Begin the background with a light area that you would like to see in your painting. Since you will be painting over much of this layer later, pick a color that does not lift easily. Just as with the backgrounds you did before, you are trying to make a nice flow of dark through the painting, to connect major elements, and to make interesting edges and shapes. I used Winsor Violet to paint a few grapes for the depth and color. Add extra shapes along the sides of the main negative shape, as if you were painting around positive vines or grapes. You can add more shapes to this later. Keep this color on your palette for later.

Tip The majority of grapes will probably be red or pink. Use green, blue and peach as accent grapes. Your two-color combinations can be wild and fun! Also, make sure you think about where the background will be, because the darkest grape must show up against the dark background. Check your original drawing and draw some shapes into the negative space after the first wash of New Gamboge. These shapes will add layers to the background and help you keep the composition in mind while painting.

4 | Underpaint the Grapes

Base the major grapes with two colors wet in wet and reserve a white highlight. Background grapes can be only one color with no highlight if in shadow. Refer to page 54 for techniques and colors. Draw the reserved shapes on the first background layer.

BUILDING LAYERED BACKGROUNDS

First, draw any positive shapes you want to leave white, then paint the entire background a light color. Let dry. For the second layer, draw some positive elements such as grapes, leaves or vines, or simply abstract shapes with curvy edges on the first layer and paint around them with a little darker background color. This negative painting will make the positive shapes that you just drew stand out. You could cover the whole background with this second layer or just make an interesting flow of color through the painting. For the next layer, draw some more shapes and paint around them with a color that is darker than the last layer.

The idea is to build positive shapes and to darken each successive layer. Later, the shapes you drew on the lighter layers can be painted with other colors, if you wish. Layering gives you an interesting interplay of light shapes on dark and vice versa. Try to keep the darkest layer behind your center of interest for a good value contrast. This technique is a fun way to do a background, and it will keep your creativity flowing! You can do as much or as little as you like.

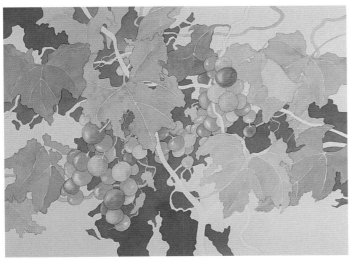

Paint the Second Background Layer

5 Draw some positive shapes on the first background layer, perhaps vines or more leaves, or maybe just shapes of any kind. You'll paint around these shapes and either leave those colors or paint over them if the first layer is light enough. Draw a vine through the background, extending it into the light area, and fill in the extension with the first background color for an interesting mix of positive and negative. Use a color compatible with, but darker than, the first layer. I used relatively thin Winsor Violet +Winsor Blue (Red Shade.)

Define the Leaves

6 Add touches of extra color for variety, especially Burnt Sienna and Winsor Red. Shade around veins and where two leaves overlap. For shading greens, use Hooker's Green + French Ultramarine Blue and Sepia. For the golds, use Quinacridone Gold + Sepia. For the blues, use French Ultramarine Blue + Sepia.

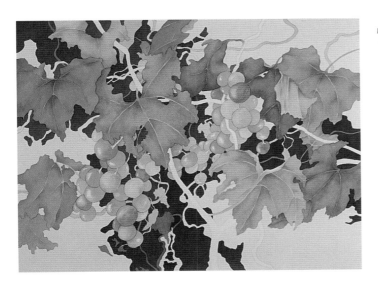

Paint the Third Background Layer

7 Draw some more positive shapes to be retained from the second background layer. Then mix a darker, compatible color and paint over the second layer. This will probably be your last background layer, so make sure it's dark enough. Use Winsor Violet + Winsor Blue (Red Shade), but with more pigment than in the second layer, and add enough Burnt Sienna to gray the neon blue.

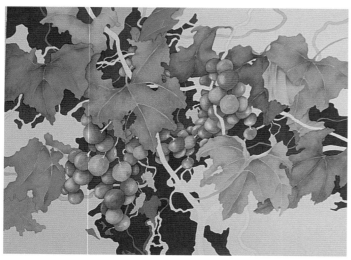

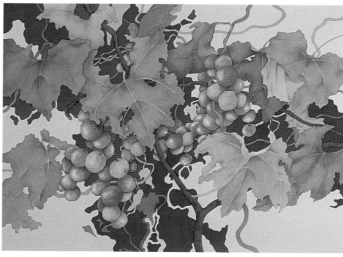

8 | Detail the Dimensions

Round the grapes by adding more intense color and using other colors and leave some texture marks. Shadow the grapes behind or beneath others and where colors are too similar. Zing some of the reds with touches of yellow or orange. Painting the crevice darks will really make this section come alive. Refer to Step 2 on page 54.

9 | Vines and Branches

Mix a puddle of Burnt Sienna and paint the branches. Add French Ultramarine Blue + Sepia wet in wet along the bottom side of the branches. You can paint the vines any color you like—go a little wild!

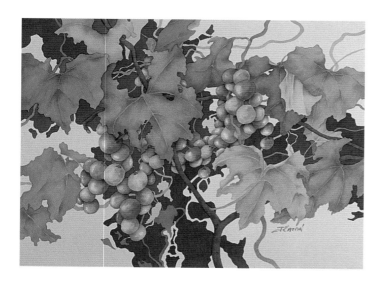

10 | Texture and Evaluation

Texture the grapes as in step 3 on page 54 and restate any crevice darks that need it. Check your values and colors. A thin glaze can change a color just enough to create more color harmony.

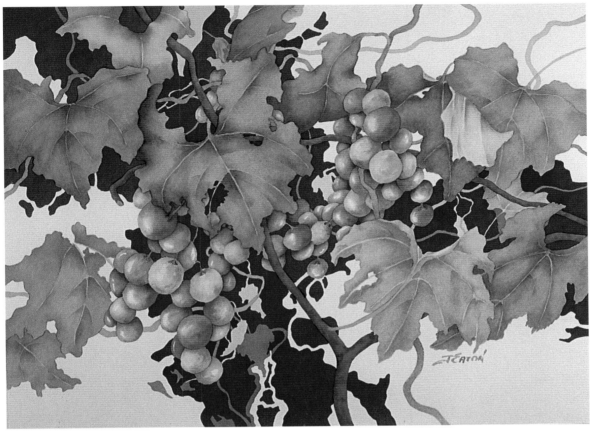

Final Touches

11 Add more contrast to the shading on the green and blue leaves with French Ultramarine Blue + Sepia, and add Quinacridone Gold + Sepia on the tan leaves. Add hints of other veins with negative painting. Glaze the dark area once more with Winsor Blue (Red Shade) + Winsor Violet. You can do this more than once if needed. You're done! Sit back and enjoy the painting.

BOUNTY • 12" x 16" (30cm x 41cm)

3 painting FLOWERS

Flowers are some of the most beautiful things on earth. They come in all kinds of shapes, sizes, varieties and colors. You can use all sorts of techniques to paint them. One of the greatest joys of watercolor is to try new things, so let's paint some new flowers! You will start with simple shapes and techniques and work up to more involved flowers and backgrounds. You will also explore some new materials and ways of seeing as you paint. Once you have mastered the basics in these five easy-to-follow demonstrations, then you can combine the composition lessons with your basic flower know-how to create dramatic paintings on your own. You also can look at the gallery in the back of the book to get some ideas and inspiration. Let your imagination soar and your brush fly!

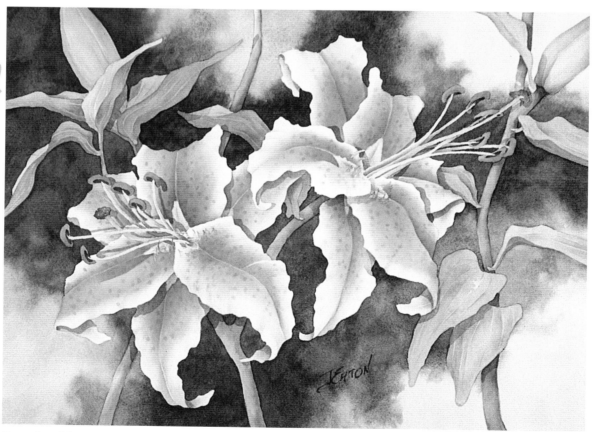

Sensational Stargazers
You'll learn how to do this beautiful and elegant stargazer lily painting on pages 71-77.

TRIBUTE TO THE STARS • 12" x 16" (31cm x 41cm)

Delicate Daylilies

We built our first home on land that had once been part of a nursery. You can imagine my surprise and delight the first June when several hundred daylilies began to bloom on the outskirts of our yard. The daylily has been one of my favorite flowers ever since. It's a very simple but sensuous flower, and the blending of one color into another and the white edges in some places make it fun to paint. It comes in many colors, but one of my favorites is a beautiful peach.

When you are trying something new, often you might want to practice it to work out exactly how to do it and what colors to use. Some practice will make you feel a lot more comfortable and paint more freely when you go to the actual painting.

Reference Photos
Here are the two reference photos I used for this painting. Remember, reference photos help give you an idea of what something looks like, but you don't have to re-create the exact image. Feel free to add, subtract or use as much artistic license as you would like. Have fun and make your paintings say something about you!

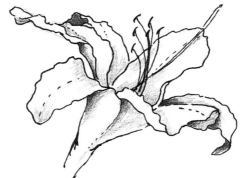

Various Views
These four views of the daylily give you an idea of how it looks from different angles—and will help you complete a drawing for the demonstrations on pages 62 and 63-66. It has three petals on top, three petals underneath, six anthers and filaments and a long style.

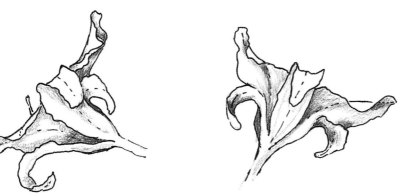

Tip Flower anatomy can be a tricky thing to remember. Try copying the anatomy chart on page 13 and putting it next to your workspace for every demonstration. Soon enough you will memorize the terms and be able to fly right through the steps!

Practice Your Petals

Flowers aren't very hard to paint once you learn how to break them down into more manageable parts. The good news is that despite their overall differences in appearance, flowers all share the same anatomy (see page 13). It's these common elements that help you link the various lessons and feel confident painting any flower.

Try your hand at the basics with this mini demonstration, then move on to a more complicated daylily composition. You will be using the same materials for the next full painting on pages 63-66.

[MATERIALS LIST]

- Cadmium Orange
- French Ultramarine Blue
- New Gamboge
- Permanent Alizarin Crimson
- Permanent Rose
- Quinacridone Gold
- Sepia
- Winsor Blue (Red Shade)
- Winsor Red
- Variety of round brushes—nos. 4 to 10 (use the no. 4 for the details and the larger brushes as necessary)
- Masking fluid
- Arches 140-lb (300gsm) cold-pressed paper
- Other supplies listed on page 11

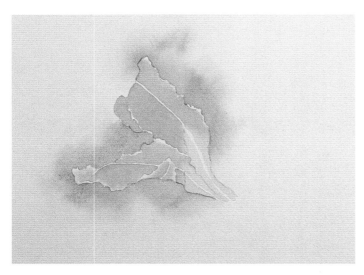

1 | Begin with the Basics
Mix the peach color using a light, watery mix of Winsor Red and New Gamboge + a touch of Winsor Blue (Red Shade). Paint the top of the petal, leaving a few white edges and a line down the center. Add New Gamboge wet in wet to the bottom of the petal. Put in some contrasting background colors.

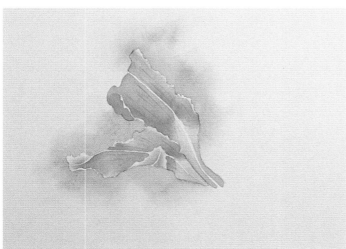

2 | Highlight the Sun Spots
Using New Gamboge, paint highlights where the sun might hit. Paint the bottom of the yellow areas on the petals and the stems with a green made from New Gamboge + Winsor Blue (Red Shade) + a touch of Permanent Rose to gray the green. Put another layer of peach on the brightest part of the local color, but stay out of the sunlit area. Make some vein lines with the same peach.

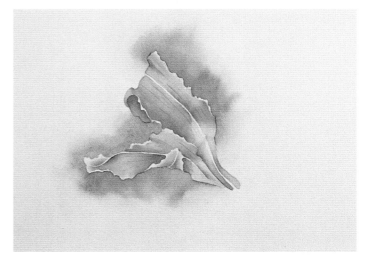

3 | Intensify the Local Color
Paint the shadowed areas with French Ultramarine Blue + Sepia. Intensify the local color with another layer of peach where the color is brightest. Darken the deepest shadow areas with Winsor Blue (Red Shade) + Sepia.

Daylily

Now get ready to begin your journey into creating beautiful floral compositions in watercolor! For most paintings, the getting-ready step will be the same as the process that you used on the leaves. Don't be afraid to look back on pages 61-62 for the reference photos and drawings. You will be using the same materials list as on page 62.

1 | Get Ready to Paint
Complete the getting-ready step. Mask the stigma, style, anthers and filaments (see flower cross section on page 13) so you can paint over them without worry. You could also mask the white stripe down the middle of the petal if you wish. Decide which direction the light is coming from, and put an arrow to the side of the painting so you won't forget!

2 | Underpaint the Petals
Lightly base paint the petals as you did in the practice petal. First, paint every other one so you won't have a problem with paint soaking into the petal next to it. Be sure to leave a few little white rims on the ruffled edges, especially where one petal overlaps another.

ABOUT MASKING FLUID

You can use masking fluid to save whites when painting around them would be tedious or when the paint behind them needs to be applied very freely.

Prepare your brush by wetting it thoroughly on a bar of soap, coating the bristles. The soap will protect your brush from the masking fluid permanently adhering to it. Pour a little masking fluid on an extra piece of paper and recap the bottle so the fluid doesn't dry out. Apply the mask to the areas in which you want to preserve the whites and allow it to dry completely before painting. Wash your brush well with more soap and water as soon as you are finished masking. When your painting is finished, you can remove the mask with your fingernail, but a rubber cement pickup from the art store works better. Don't leave masking on the paper for more than a few days to avoid discoloration. The very hard edges that appear when you remove the mask can be softened with gentle scrubbing using a wet brush if you have used nonstaining colors. Often painting around whites is simpler and more effective than masking, but when you need it, it's a great tool.

Tip Transfer your drawing to your paper and keep the original drawing on hand. Once you start painting, you may not be able to see all your pencil lines. Think of it as a road map to your composition!

3 | Perk up the Petals

Paint the petals between the ones already done. Scrub gently if a hard line forms anywhere between the peach and the white ruffle. Paint the highlights, veins, green petal bottoms and stems as you did on page 62. Begin the shadowed areas lightly.

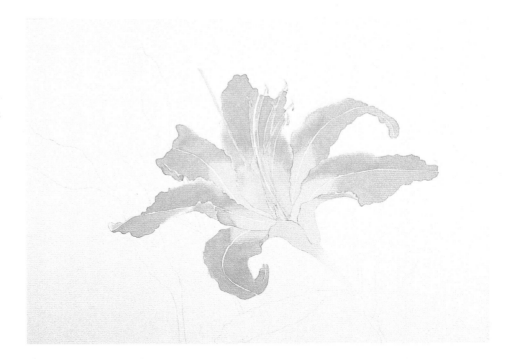

4 | Layer the Local Color

Bring up the local color with another layer of peach. Intensify sunlit and shadowed areas with an additional layer of color if needed. Add more of the shadow color to the areas underneath or behind other parts of the flower, using the darkest shadow color in the deepest shadow areas.

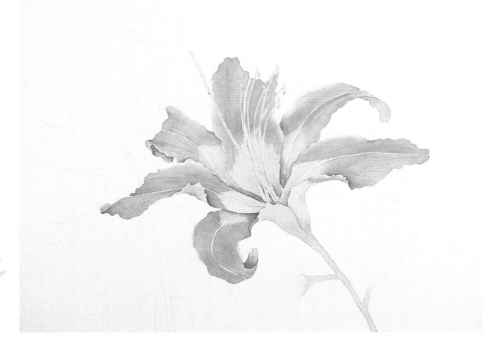

Tip The first light wash you put on something is called the under-painting. These first washes give different casts of color to the final layer. Underpainting helps you see more easily how things overlap and where you need to work on color and value changes to show the differences between adjacent leaves and/or petals.

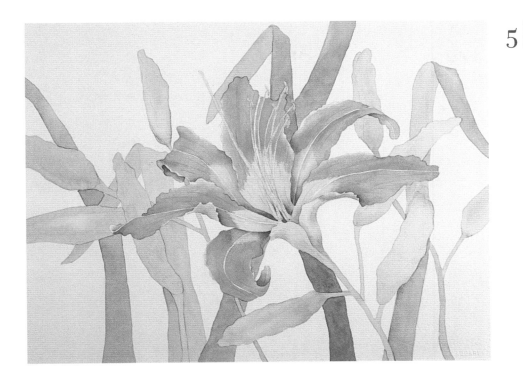

5 │ Mix Your Colors for the Best Results
For the leaves, use Winsor Blue (Red Shade) and New Gamboge to mix three varieties of color—green, blue-green and yellow-green. To gray any of these, add a touch of Permanent Rose or Permanent Alizarin Crimson to the mix. Where light hits the bent places of the leaves, use just New Gamboge in the first layer of paint. For the buds, use the same peach, yellow and greens that you have already mixed and try to paint each one a little differently. Shadow with French Ultramarine Blue and Sepia. Intensify sunlit and shadowed areas with another layer of color if needed. Add another layer of shadow color to the areas underneath or behind other parts of the leaves, using the darkest shadow color in the areas in deepest shadow.

BACK TO THE DRAWING BOARD

Tape your tracing paper over the painting and decide where the leaves would go best. Draw the leaves to form a background for the flower and set them behind as many white ruffles as possible. You can add more leaves later if you need to. Vary the shapes by bending some and slanting them in different directions. Make some of the leaves go off the edges of the painting and use them to move the viewer's eye around your composition. You'll also need to create variety in the buds. The real buds don't have so many lumps and bumps, but they make a more interesting composition. Transfer the drawing.

Before you paint, think about which leaves are in the back because they will be the darkest or the most blue, if possible; decide which leaves and buds overlap because they will need to be different colors or values. Keep the first washes rather light for easy correction. Using a white or light background allows you to play around with the composition until the very end.

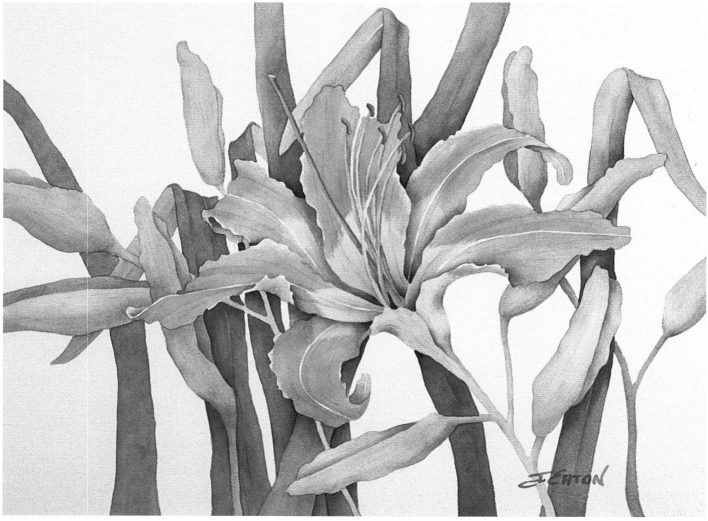

Final Touches

6 Add to the composition if needed. Intensify shadows with a wash of purple made from Winsor Blue (Red Shade) + Permanent Alizarin Crimson, especially in the flower center and where things overlap. Use Quinacridone Gold or Cadmium Orange to make the highlights brighter. Add any touches of extra color to the leaves or buds (purple, red, yellow). Finally, unmask the stamen and wash the filaments and style lightly with orange or gray or purple. Create a darker line on the shadow side and soften the edge. Use orange on the anthers with a little dark shadow on the underneath. Congratulations! Your first flower painting is done. Take one last look at color and value, make any final corrections, and sign your name.

ONE A DAY • 12" x 16" (30cm x 41cm)

Tip Don't be afraid to experiment or change elements in your composition. In the last step, I added two more leaves to the left of center to make the flower, especially some of the white ruffles, stand out more. This also helped make the white negative space more interesting.

Hibiscus

The hibiscus is another one of my favorite flowers, but then, what isn't! Flowers are a little like children; you love them all, each for their separate qualities. Actually, a lot of us aren't terribly fond of dandelions, but when your child proudly brings you a fistful, even they seem quite charming.

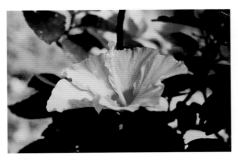 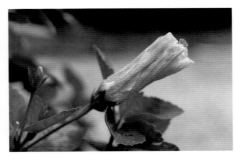 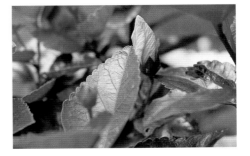

Reference Photos
Use these photos as inspiration for your watercolor. Remember, the important thing is to be creative, not to perfectly render every detail of the images.

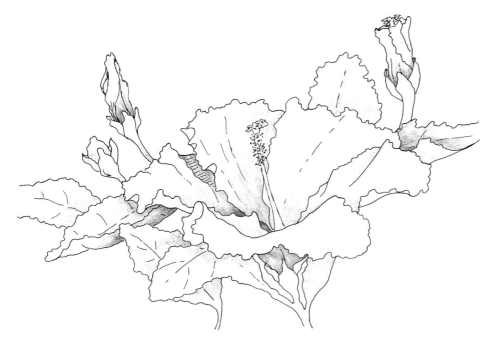

Create a Composition
Using the reference photos above, try creating your hibiscus composition. Remember, you don't have to use every element in the photos in your painting. Think of the photos as basic ingredients of your watercolor masterpiece. My interpretation is shown on the left. It will also be used in the demonstration on pages 68-70.

Let it Flow with Hibiscus

This hibiscus painting is fun to create because of its flowing, ruffled petals, so you can add doing ruffles to your repertoire of painting knowledge. You'll also do a wet-in-wet background, which takes advantage of watercolor's unique qualities. Of course, this hibiscus is rooted in reality but grown with a touch of imagination, especially in its colors. Just let your creativity flow!

Tip Don't go back into a painted area that has begun to dry because the new paint will eventually form hard edges. You can darken or change an area easily enough, but you must let it dry thoroughly. Once dry, you can re-wet it and change anything as necessary.

[MATERIALS LIST]

- Burnt Sienna
- Cadmium Orange
- French Ultramarine Blue
- New Gamboge
- Permanent Alizarin Crimson
- Sepia
- Winsor Blue (Red Shade)
- Winsor Red
- Masking fluid
- 1-inch (25mm) flat and a variety of round brushes—nos. 4 to 10 (use the no. 4 for the details and the larger brushes as necessary)
- Arches 140-lb (300gsm) cold-pressed paper
- Other supplies listed on page 11

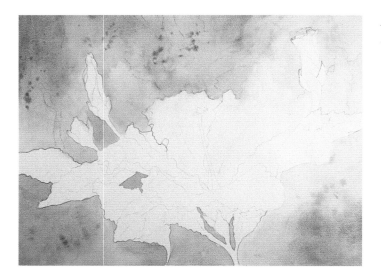

1 Begin the Background

Use the composition from page 67 and complete the getting ready step. Mask the stamen, including the little hairs toward the top of the style. Mix five, individual puddles of New Gamboge, French Ultramarine Blue + Sepia, Winsor Blue (Red Shade) + New Gamboge, Permanent Alizarin Crimson and Cadmium Orange. Keep the values light to medium, as you will be using them throughout the demonstration.

Wet the paper several inches away from the hard edges of the positive space. Paint from the edges of the positive space to the wet paper and soften the edge until there is no color left. Work another area while the first dries. Extend the painted area until you have covered the whole background by re-wetting a dry area, painting further and softening the edge. Turn the painting upside down to paint around the hard edges at the top.

Add some interesting color patterns, and make sure they're light enough to add another layer if desired. Flick drops of color from a fully loaded brush by snapping the brush down with your whole arm, not just your wrist, over a wet area. If you can't get the flicking done as you are painting the first wash, just let everything dry, re-wet the area and flick. Cover any areas you want to protect , or check them immediately and wash off any stray flicks with clear water.

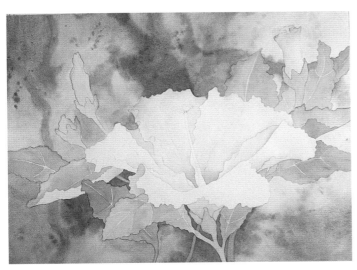

2 | Separate Your Colors

Mix Winsor Blue (Red Shade) + New Gamboge to make green, yellow-green and blue-green and differentiate the leaves and stems. For contrast, edge some of them with Burnt Sienna. Begin adding color to the flower and separating the petals by putting darker shades in the shadowed areas and lighter ones where the sun would hit.

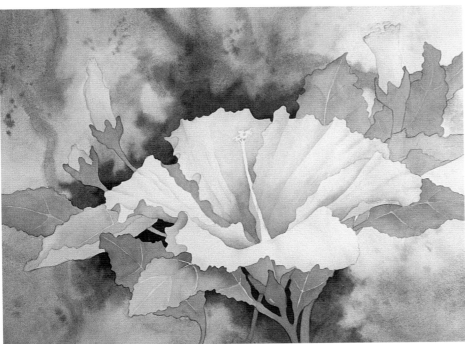

3 | Ruffle the Petals

Use more color to define the petals, leaves and the inside of the flower. To make ruffles, first decide which side of the ruffle would be in the brightest light—that will be the hardest edge. Paint along the edge with a darker version of the colors already used in the petal and soften the other side of your stroke. In some places, follow the ruffle line down the petal with a thin wash of color, skipping places so the viewer's eye can fill them in. Add to the background darks, wet in wet.

WORK THE WHOLE PAINTING

As you continue painting, you will be working back and forth between the background and the flowers and leaves. When you change or add to one thing, other parts of the painting will have to be adjusted accordingly. Working the whole painting a bit at a time usually has a more harmonious result.

Toward the very end of this painting, I added another leaf to cover the light space at the right of the bottom petal and washed a thin layer of Cadmium Orange over the background lights on the left side to give more warmth and tie in that area. Don't be afraid to add to the background; just be sure to maintain rather soft edges. Now is the time to slop your paint around a little and enjoy being free with it!

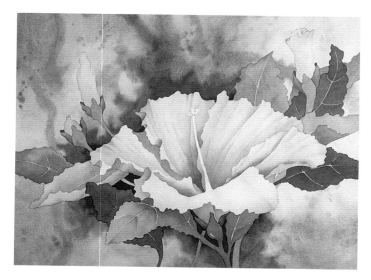

4 | Work on the Values

Keep defining petals and leaves with additional layers of color. If using the same color doesn't make enough difference, use its complement to gray it or use a wash of purple (French Ultramarine Blue + Permanent Alizarin Crimson) or blue-gray (French Ultramarine Blue + Sepia) to darken it. Make sure the background darks are forming a pattern that flows through the painting.

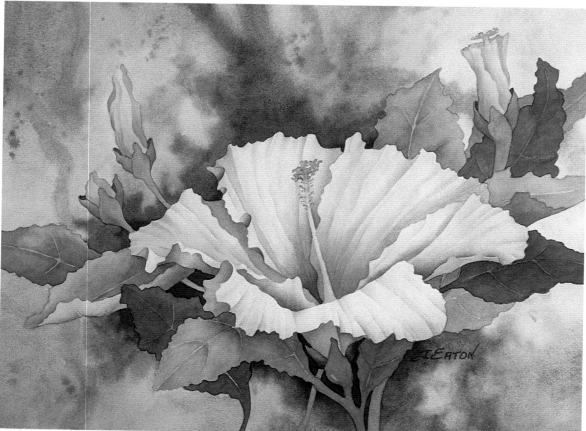

5 | Final Touches

Further define the buds with purple (French Ultramarine Blue + Winsor Red) for shadows and Cadmium Orange for the warm inside area of the petals and for the stigma. Complete the ruffles, varying the spaces between them. Add to the background wherever needed. Unmask the center of the open flower and paint the style light Cadmium Orange and the stigma with bright Cadmium Orange shadowed with Cadmium Orange + Sepia.

CARIBBEAN TREASURE • 12" × 16" (30cm × 41cm)

Striking Stargazer Lilies

One day I was wandering through a nursery and kept getting a whiff of the most wonderful smell! It was my first introduction to stargazer lilies. They were such elegant and beautiful flowers that I bought a potful and took them home to paint. They perfumed the whole house and the only disappointment was that I couldn't paint their fragrance in addition to their striking color and their sinuous shapes. The bonus, however, was that the flowers went to the garden after posing and they have bloomed each year since!

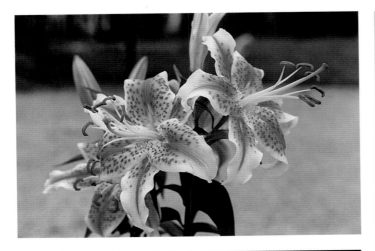

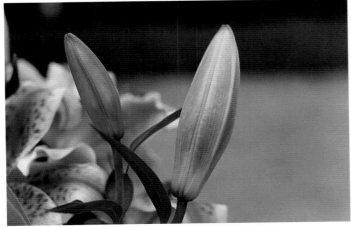

Reference Photos
Aren't these flowers gorgeous? I just love the bold colors that seem so alive on the petals.

Stargazer Lily

The stargazer lily is similar to the daylily, but its petals spread out from the base in a different way, the color pattern is completely different with its textured dots and little hairs, and the leaves are different. Take your time to complete this demonstration. You will not only have a beautiful and instructive composition when you are done, but these lovely colors will liven up anyone's day!

[MATERIALS LIST]

- Burnt Sienna
- Cadmium Orange
- French Ultramarine Blue
- Hooker's Green
- New Gamboge
- Permanent Alizarin Crimson
- Permanent Rose (or substitute Winsor Red)
- Sap Green
- Sepia
- Winsor Red
- Winsor Violet
- Optional paint: Opera by Holbein
- Masking fluid
- 1-inch (25mm) flat and a variety of round brushes—nos. 4 to 10 (use the no. 4 for the details and the larger brushes as necessary)
- Arches 140-lb. (300gsm) cold-pressed paper
- Other supplies from page 11

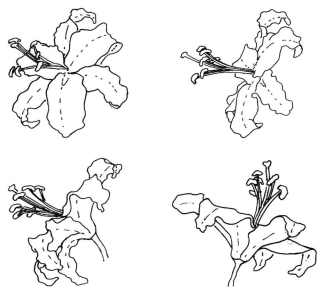

Various Views
These four views of the stargazer lily show you what you'll see as it turns in different directions.

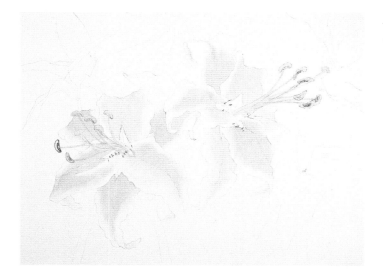

Maintain the Whites

1 Complete the getting-ready step as outlined on page 12. After you transfer the drawing, mask the anthers, filaments, stigma, style and a few little hairs on those petals that are turned sideways and are closest to the viewer. Don't mask along the edges of the petals because you don't want a hard, white line.

After the masking is completely dry, use a thin wash of Winsor Red to paint the middle of the petals. Maintain the white along the edge by wetting the edge first and painting into it. Keep the paint far from the edge, because it will bleed a long way. You don't have to leave a white streak in the middle of the petal.

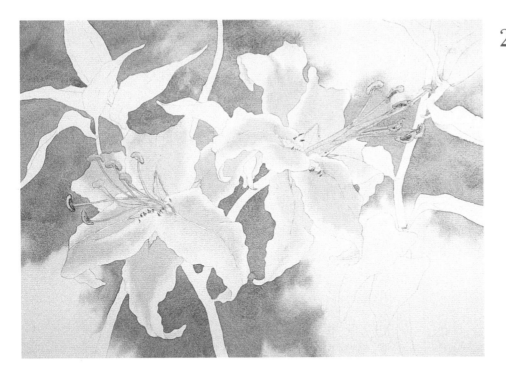

2 Begin the Background

Mix French Ultramarine Blue + Sepia for a light gray and begin to establish the darker background areas using either the flat or a large round. Make the areas flow through the painting and put them behind most of the white edges on the petals. Soften the dark edges, let dry and then extend them. Add some green shades (Hooker's Green, New Gamboge, French Ultramarine Blue and Sepia) and some Permanent Alizarin Crimson wet in wet for variety. Don't worry about these first grays too much; they are only a blueprint. Add another light layer of Winsor Red to the petals, and touches of New Gamboge inside the center **V** and where the petals will be highlighted. Use a small round brush.

Tip Strengthening the values in both the background and the flower will show you how they go together. When you develop the dark pattern in the background, you can stop short of the boundaries you already have or you can expand them. Now is the time to play around with it a little.

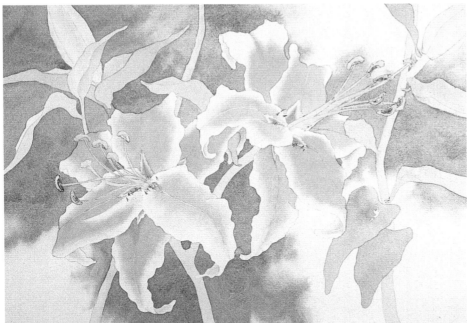

3 Base the Greens

Make three green puddles by combining Hooker's Green and New Gamboge. One puddle will be your yellow-green. For the next, add a touch of Permanent Rose or Winsor Red to gray it for your basic green. Add French Ultramarine Blue to the last puddle for a blue-green. For a darker green, add a touch of Sepia to the blue-green. Paint the leaves using different greens for contrast. Use the blue-green for the very center of the petals, leaving a yellow rim. Base the buds with Winsor Red and New Gamboge.

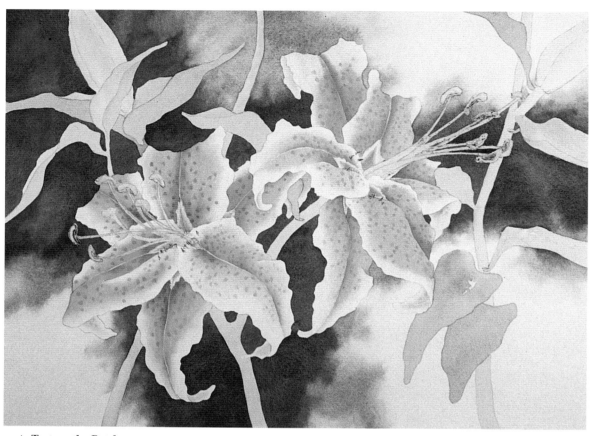

Texture the Petals

4 | Paint another layer of French Ultramarine Blue + Sepia on the background, adding other colors wet in wet as you did before. You can change the boundaries, just remember to soften the edges. Darken the center of the petals by adding a light layer of Permanent Alizarin Crimson + a touch of French Ultramarine Blue, leaving a lighter vein in the middle, and soften the edges. Put in the texture spots on the petals with the same Permanent Alizarin Crimson mix. Touch a spot of it to the paper, let it sit for five to ten seconds, then blot it once with a clean, damp brush to soften the edges. Practice this first so you will know how long to wait until you blot. Blotting should soften the edges of the spot without washing the spot away. If it doesn't work, you have too much water. Switch to a smaller brush that carries less water, and blot it on a paper towel more thoroughly before you blot the painted spot.

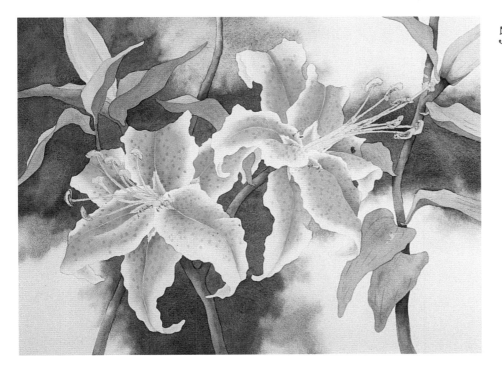

5 | **Develop the Leaves and Buds**
Differentiate the leaves using your three green puddles for the inside and the outside and for overlapping leaves. When both sides of the leaf show, paint the lighter color on the whole leaf, dry and paint the darker color on the darker side. You can leave some hard-edged light spots where the sun would hit. Use Burnt Sienna and Cadmium Orange to paint highlights where two similar-value greens come together. Develop the buds with layers of New Gamboge and thin Winsor Red, leaving stripes where the petals will have veins. Shade with your gray mixture. If the petals need more color, wash on more Winsor Red or Permanent Alizarin Crimson. Warm the white petal areas with touches of light Cadmium Orange.

Tip The size of the positive and negative spaces will depend on how large you choose to do your composition. Therefore, use the largest or smallest brush you feel comfortable with.

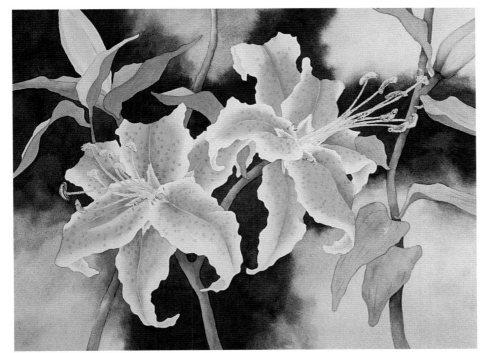

6 | **Back to the Background**
Reinforce the darks in the negative space once more. Don't complete the flower until you see just how dark the darkest places in the background will be.

Bring it All Together

7 Use French Ultramarine Blue + Sepia to shade the bends and ruffles in the petals. These petals don't have sharp ruffles like the hibiscus, so soften both edges of the ruffle shading. Define the leaves by painting areas between the veins with a green just a shade darker than what's on them now. Just give a hint of veining and let the viewer's eye fill in the rest. Fill in any necessary areas in the negative space with either dark or light colors. You can subdue any area that is too bright by washing over it with the complement of the main color.

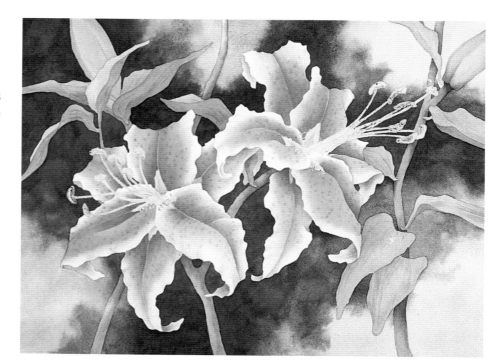

Final Flourishes

8 If needed, put a last layer of color on the petals. In a few places, I used a light wash of Opera for a glow. Put in the cast shadows with French Ultramarine Blue + Sepia.

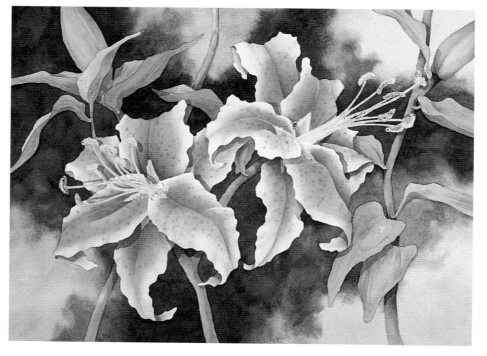

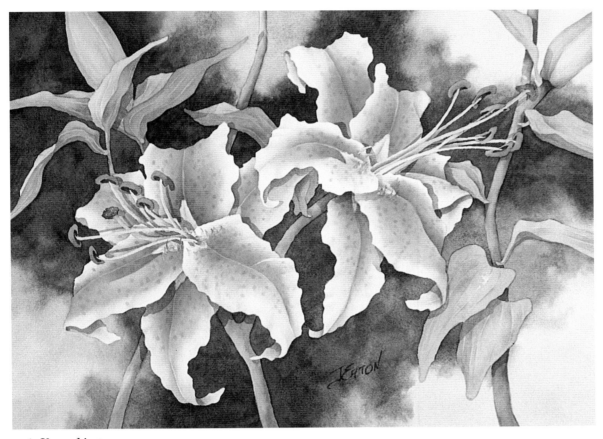

9 | Unmasking

Remove the masking with your rubber cement pickup. Paint the styles and filaments with a light wash of Sap Green + New Gamboge + Permanent Rose. Let dry and use other colors from your green puddles to differentiate them. Paint the anthers with Cadmium Orange + Winsor Red, dry and add touches of Cadmium Orange + Permanent Alizarin Crimson. Paint the stigma with light Winsor Violet and add touches of Cadmium Orange and Permanent Alizarin Crimson wet in wet. Use Cadmium Orange, Permanent Alizarin Crimson and Sepia for the dark interiors. Touch the darkest interior part with French Ultramarine Blue + Sepia to add dimension. Paint the little hairs Winsor Red and soften the bottom. Add touches of color or dark anywhere you need it. Your stargazers are complete.

TRIBUTE TO THE STARS • 12" x 16" (30cm x 41cm)

Sunflower

Isn't it fantastic to be dwarfed by a flower! Stand under it and look up into it. Sunflowers can be gigantic, and they take all kinds of weird shapes. Their petals can droop or point upward to the sky. What a perfect flower to send your personal imagination on an absolute binge. Since this book is about interpretation, you can interpret the heck out of this one. Artistic license, here we come!

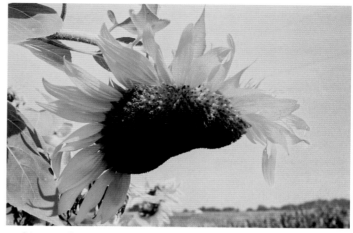

Reference Photo
Sunflowers are exciting flowers that deserve exciting techniques. This gigantic plant inspires countless tales of the fantastic. So let your imagination soar!

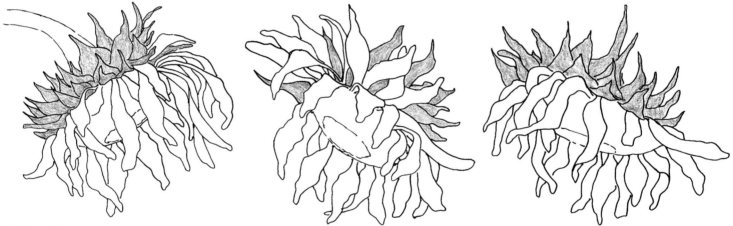

Various Views
Sunflowers take all sorts of shapes, but try to limit your selections. Put a lot of green sepals in the crown around the yellow petals. Long points on some of them lend excitement. The petals extend from under the crown. Don't forget to show the petals coming from behind the flower. The center of the flower will be oval with a soft oval indentation in the middle of it.

Simple Sunflowers

So far you have done flowers with very simple petals. The sunflower is no different. It just has a lot of simple petals. It looks involved, but you'll be surprised at how easy it really is. You'll also try a layered background again, like the background for the grapes-and-leaves demonstration on pages 55-59, which can be as intricate or as simple as you want. You can do just a little of this or make it very involved.

[MATERIALS LIST]

- French Ultramarine Blue
- Hooker's Green
- New Gamboge
- Quinacridone Gold
- Winsor Red
- Winsor Violet
- Cadmium Orange
- Burnt Sienna
- Sepia
- Winsor Blue (Red Shade)
- 1-inch (25mm) flat and a variety of round brushes—nos. 4 to 10 (use the no. 4 for the details and the larger brushes as necessary)
- Arches 140-lb. (300gsm) cold-pressed paper
- Other supplies from page 11

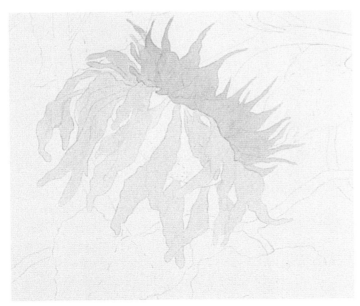

1 | **Begin the Crown**
Follow the usual getting-ready step, but this time your composition will be very simple since you will add to it as you paint. Draw one sunflower and some artfully arranged leaves and vines. Don't mask anything.

Paint all of the crown with a light yellow-green mix of Hooker's Green + New Gamboge + a touch of Winsor Red to gray it. Paint all the petals with New Gamboge.

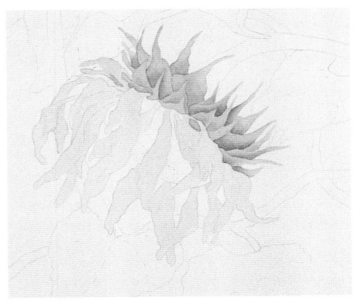

2 | **Define the Sepals**
Add French Ultramarine Blue to the yellow-green mix and paint behind each of the sepals to make the one in front stand out. Leave a hard edge behind each sepal and soften the other end of your stroke. A no. 4 or 6 round will give you the best stroke control here.

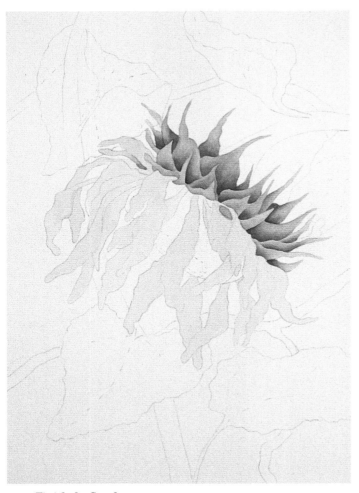

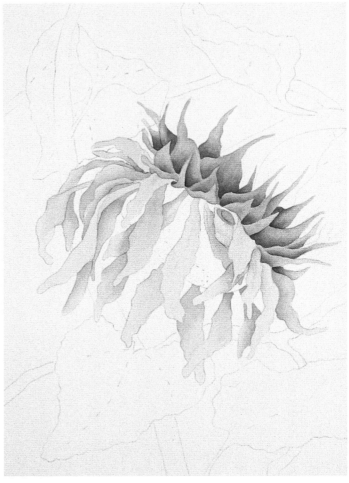

3 | Finish the Sepals

Mix some Winsor Blue (Red Shade) and Winsor Red into the green mix for a darker olive green to use at the very bottom of some sepals. Add some thin Winsor Red and some thin Cadmium Orange in the lighter green places and darker areas for variety. In the darkest crevices, use Winsor Blue (Red Shade) + Winsor Violet. Darker colors will go behind most of this, so keep it rather light.

Tip Some of the petals will require tighter control, so keep your no. 4 round handy. For the larger, looser petals, you can use a large round brush.

4 | Overlap the Petals

Define all the petals by painting adjacent or overlapping petals different colors. Keep the ones closest to the viewer lighter and more yellow, and the petals that come from behind more orange. This takes some imagination, but the whole petal doesn't have to be the same color. Sometimes just shading the back petal on one side will do. Use any of the yellows and then mix them with Winsor Red, Cadmium Orange or Burnt Sienna for more variety. Also use Winsor Violet or French Ultramarine Blue for mixes and shading.

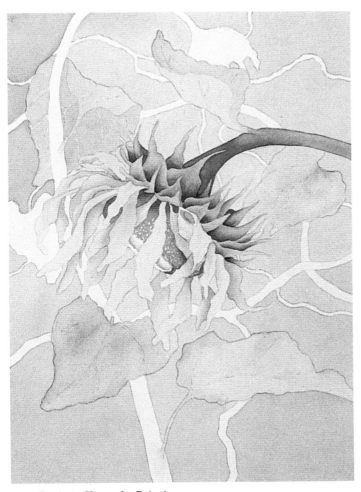

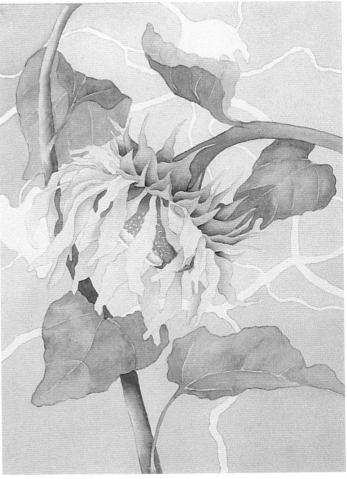

5 | Begin to Shape the Painting

Wash Burnt Sienna on the oval center, leaving white specks of paper for texture and leave the very center white. Let dry. Paint Burnt Sienna on the bottom of the inside center oval and soften. Use Burnt Sienna + Sepia for the top shadowed area under the sepals. Underpaint the stem with yellow-green; let dry. Base some of the leaves with the yellow-green paint. Add French Ultramarine Blue for a cooler green. Define the stem behind the sepals with the cooler green puddle and then add Winsor Blue (Red Shade) and Burnt Sienna immediately behind the sepals. Add Burnt Sienna to places in the leaves where a contrast is needed. If you want to add some shapes to the background, draw them in now and paint the rest of the background a light blue-gray mix of Winsor Blue (Red Shade) + Sepia.

6 | Finish the Leaves and Vine

Darken the leaves using the same mixtures that you used on the crown. Highlights are done with Burnt Sienna and the darks are done by adding French Ultramarine Blue wet in wet. Paint around some veins. Add a thin layer of Winsor Red to the flower center, painting around the white spots. The safest way to paint the large vine is to use three layers, drying between each. Paint the left side with New Gamboge and soften. Paint the right side with medium green and soften into the yellow-green. Paint the extreme right side with dark green and soften into the middle.

Tip The key to building a powerful layered background is to build shapes by darkening each successive layer. This technique can be tricky, so you may want to check back on page 56 for detailed instructions.

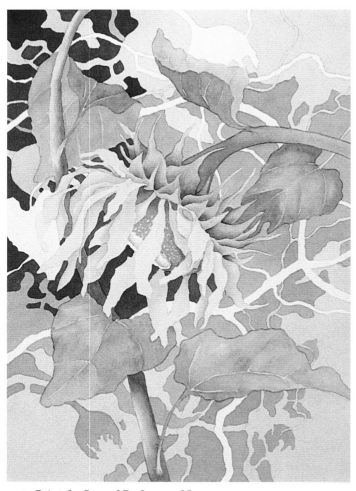

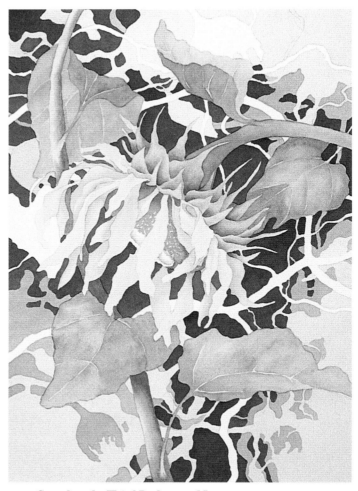

7 **Paint the Second Background Layer**

Draw some more positive shapes on the blue-gray background for the second layer. Add more Winsor Blue (Red Shade) + Sepia to deepen your original puddle for the background. Paint around these new shapes, making curvy edges wherever you stop. Make this second layer extend to all four edges with a different size and position on each edge. You are looking for three things—a nice flow of dark color, a darker background behind the flower to set it off and a few additional positive shapes that are the pale blue-gray of the first layer.

For the third background layer, draw a few more positive shapes on the second layer and add more of the same pigments into the blue-gray mix to darken it again. Paint over a lot of the second layer, but leave some positive shapes of the medium blue-gray uncovered.

8 **Complete the Third Background Layer**

The third layer will be the darkest and will go on top of the second layer. You may have to build more than one layer in an area to create a dark value. Put this darkest layer behind the flower and make it go to each of the four sides of the painting, but leave some of the second layer showing. Leave some background areas untouched because the eye needs a quiet place to rest with all these shapes happening on the paper. Now you should have a background with shapes in light gray, medium gray and dark gray. At this point you could decide to make the background even darker, but it is better to finish the petals before you decide.

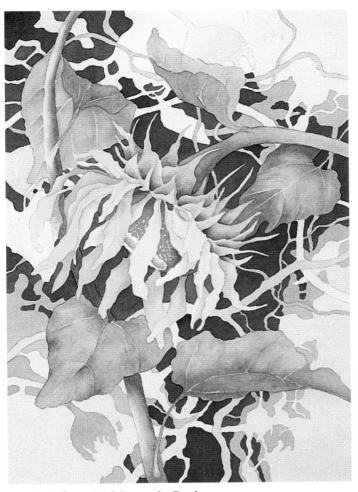

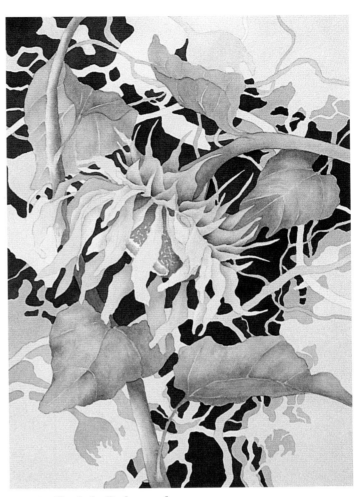

9 | **Reinforce the Color on the Petals**
Brighten the petal colors and make sure you can tell one from another by changing the color or shading. Where the leaves do not stand out enough from the background, deepen the leaf color with the same colors as used before + French Ultramarine Blue. Paint the small vines. Any color that will harmonize is fine. Paint the remaining white shapes. If they have become distracting, use a subdued color like the background. If you want to emphasize them, use a contrasting color that will make them stand out.

10 | **Check the Background**
If the darkest background color isn't dark enough, give it another layer of the same mix. You can also make subtle changes by layering with its complement. If you want to add a few more dark places, begin the layering now.

Tip Helpful colors for finishing the petals are New Gamboge, Quinacridone Gold, Winsor Violet, Burnt Sienna, Cadmium Orange and Winsor Red.

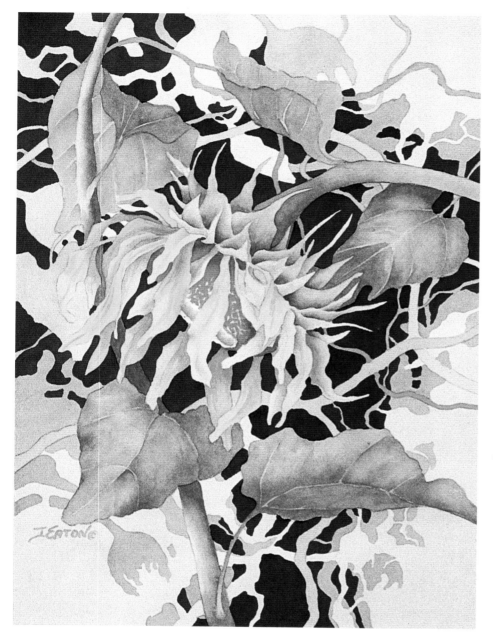

Final Touches

Add some subtle hard-edged brush-strokes to the petals and complete any necessary shading. Often, brushstrokes indicating a bit of direction bring everything to life. Generally, use colors close to the petal color itself, but violet works well here, too. Reinforce edges where value changes need to be greater. Adjust color in the small vines. If the lightest background color areas need some added zip, wet an area and paint another color into it. That will give a gentle grada-tion and add interest without distr-action. Give some of the darkest areas more variety and warmth with Winsor Red + New Gamboge (a very transparent orange). Sign your name. Now you've done a flower with lots of petals, but it wasn't so hard, was it?

BIGGEST SHOW IN TOWN • 12" x 9" (30cm x 23cm)

Bonus Lesson—Hot-Pressed Paper

It's time to try something new! So far all the demonstrations have been on cold-pressed paper, but your next painting will be on hot-pressed paper using gesso. It's interesting to see the differences paper and an extra material can make. Try the exercises on the next two pages to see how varying surfaces can affect watercolor, and have some fun with something different!

Hot-pressed paper has a very smooth surface that doesn't allow the paint to sink into it as do cold-pressed or rough surfaces. Since the pigment stays on top of the paper, it is easy to remove. A little light scrubbing will take off the color and give you a white surface again. Nevertheless, putting a second layer of paint on top of the first is hard to do without disturbing the first layer. Your paint will also react very differently on hot-pressed paper. The pigments will mingle differently and you can't soften edges easily because you will remove pigment. Before you work on hot-pressed paper, play with a section of it. Try applying paint to dry paper and to wet paper, painting on top of dry paint, splashing drops of water or spattering color into wet paint and daubing the wet paint with almost anything.

Dry Paper Doesn't Allow Colors to Mingle Well
This was done on dry paper. The colors don't mingle well, and any difference in the amount of water in the paint tends to make a balloon, a place where extra water makes a light circle. The light mark at the bottom of the red stroke is a runback from the pool of paint that didn't soak into the paper.

Spatters Won't Spread on Dry Paper
Here again, the paper was too dry, so the spatters didn't spread correctly.

Color Choices *on* Hot-Pressed Paper

Here are some ways to make the qualities of hot-pressed paper work for you, instead of against you.

Don't Let One Color Steal the Show

To make the colors mingle well, you need wet paper, but you can see that the dominant color really takes over. The best way to create soft edges with hot-pressed paper is to have it rather wet.

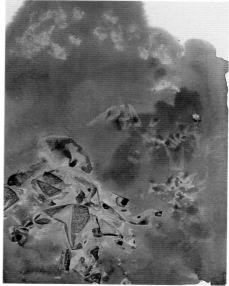

Impress Your Colors

The paint was put onto damp paper. At the top, a crumpled paper towel was pressed into it. In the center right are marks made from a crumpled piece of plastic wrap. On the bottom left side, crumpled plastic wrap was stuck on the wet paint and left until the paint had dried.

Wet-on-Wet Color Mingling

The colors mingled well because they were all painted at the same time on wet paper. The orange on the right side comes from painting a strip of yellow over the wet red. The blue and purple colors were spattered right away, and they became big blobs because they spread too much. The green on the top left was put on a little later and was more controlled. The white areas came next and were caused by the water I flicked with my fingers. The runback at the bottom of the paper was from water pooling and running back up as the top part dried quicker.

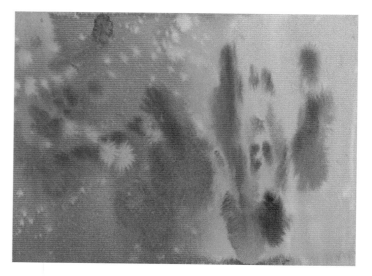

Soft Scrubbing *and* Gesso

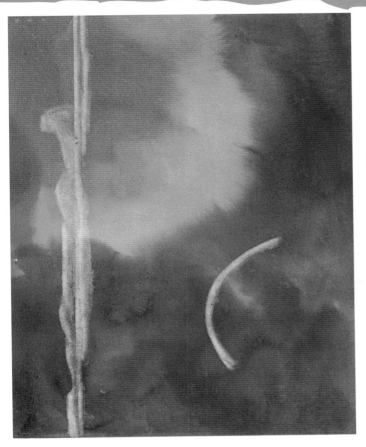

Soft Scrubbing Makes the Grade

Paint was put onto wet paper and dried. Then, soft scrubbing with the brush removed the color. To make this work, do only a small portion at a time and blot the paper immediately to keep the water from moving pigment beside the scrubbed area. You need to rinse and blot the brush after each stroke.

GESSO

Acrylic gesso is opaque and should not be placed on your watercolor palette. Any opaque white—such as Chinese White, white gouache, or white acrylic—could be used, but the properties of gesso make it especially appealing. Its drying time is quick, but not as quick as acrylic, and it mixes with watercolor easily.

Caution! You must rinse your brush every few minutes or the gesso will dry and ruin it. You should also rinse your brush twice before going back to the watercolor palette. Use one tub of water to rinse out the gesso and another tub of clean water to make sure the brush is completely clean so you don't contaminate the watercolor with opaque pigment. Mix dark, fairly thick watercolor and move it by brushloads to the gesso palette. Then mix a little gesso into it for colored gesso.

Tip You can use acrylic gesso alone as an opaque white or mix it with watercolor for an opaque color. That gives you the benefits of both water-color and oil painting. You'll experiment with this technique in the next demonstration.

Gesso Can Add Some Pizazz to Your Watercolors

Gesso is an opaque, white product usually used to prepare the ground for paint. Here it's used as an opaque white painted into wet watercolor. The watercolors need to be thick and juicy for the gesso to flow freely.

Queen Anne's Lace

Queen Anne's lace is an elegant wildflower that turns rural fields into meadows of white in the fall. It magically changes the weed patch down by the road into a thing of beauty. It is, indeed, lacy, being made up of hundreds of tiny petals. Don't worry, you won't paint all those petals. In fact, you won't even paint one petal, but it will look like you did.

One flower of Queen Anne's lace is made up of many little flower heads, which are like a miniature of the flower itself. You won't be painting all that detail, but you need to understand the general shape of the flower itself. When in full bloom it is rather flat and full with many thin stalks going to the individual flowerettes. It also has other curved stalks at its base. Its leaves are very small and won't be in the painting. When the bloom is just beginning, the stalks are more tightly closed.

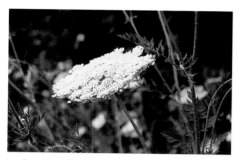 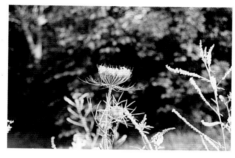 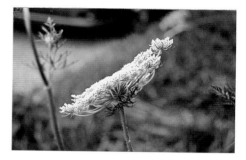

Reference Photos
Notice all the tiny individual petals that make up the flower. Aren't you glad that you don't have to draw them all!

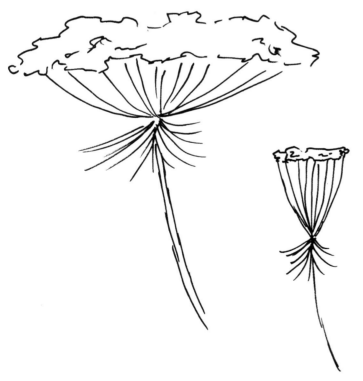

Line Drawing
Draw the flower in full bloom and more tightly closed and set them aside for reference. This time you will draw the flower as you paint. Again, a little practice will be a big help.

A Lesson in Illusions—Queen Anne's Lace

This painting will introduce you to some other options for painting in watercolor. You will use hot-pressed paper, acrylic gesso and different techniques. Be sure to read the bonus lesson on pages 85-87 before you begin. Knowing how watercolor reacts in a variety of situations will allow you the freedom to dive right into the demonstration and not get backed into a corner.

[MATERIALS LIST]

- Burnt Sienna
- Cadmium Orange
- Permanent Alizarin Crimson
- Sepia
- Winsor Blue (Red Shade)
- Winsor Red
- Acrylic gesso
- 1-inch (25mm) flat and a variety of round brushes—nos. 4 to 10 (use the no. 4 for the details and the larger brushes as necessary)
- Arches 140-lb. hot-pressed paper
- An extra palette surface (or any slick, light-colored surface)
- Other supplies from page 11

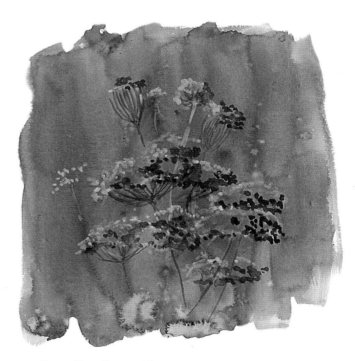

1 | The Getting-Ready Step

This time you won't do a drawing because you will draw right on the painting. Mix a large, fairly dark puddle of Winsor Blue (Red Shade) + Burnt Sienna. Add some Sepia if you want the puddle darker. Don't bother to mix this too thoroughly because having the colors separate a bit will make it more interesting. Paint the entire background using this mix and either your flat or a large round. Let your strokes show if you want, then spatter sparingly with Burnt Sienna, Cadmium Orange and Winsor Blue (Red Shade). Use a medium size round brush for the spatters (don't use too large of a brush or the spatters may get out of control). Let dry.

2 | Create Your Composition

Move some of your dark background colors to the gesso palette and mix in a little thin gesso. Remember to keep the gesso off your watercolor palette and clean your brush twice before going back to the watercolor. Mix another puddle of plain, thinned gesso. Draw your composition using the plain gesso to outline areas of blossoms that are in light and the dark gesso to outline the lower or shaded areas and blossoms that are behind others. Use a no. 4 or no. 6 round brush for these details. Remember that this is a lacy flower, so light goes through it easily. Don't worry about making a mistake because a lot of this will be covered later. You are only doing your composition now, so use just enough color to see where the flowers are. Have some overlap.

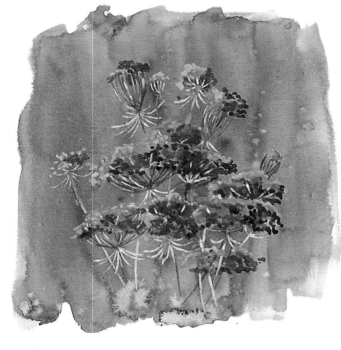

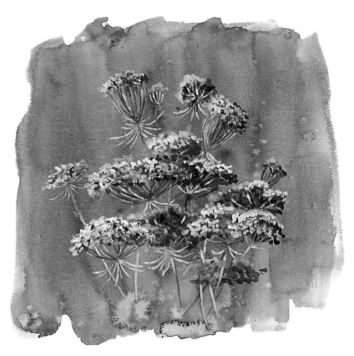

3 | **Adding Midtones**
Mix Burnt Sienna + a touch of Winsor Red. Move it to the gesso palette and mix it with gesso for a grayish tan. This is the transition color between light and dark, and will be the color of the white, shaded blossoms. Paint all the blossoms with small daubs. Wipe out some of the little stalks in the blossom itself and the main stalks with a small, well-blotted brush. Paint a few of the little stalks in with dark watercolor. Also wipe out the fringe around the base of the blossom. Use large and small round brushes as needed.

4 | **Just Picking Around**
Thin the gesso with a little water, so it won't be the brightest white, and daub it onto the areas that will be highlighted. Use any of the darkest watercolor mixes to accent the bottoms of the shaded areas and to accent a few darks in the lightest areas. Place plain Sepia and Burnt Sienna in the shadowed areas of the blossoms.

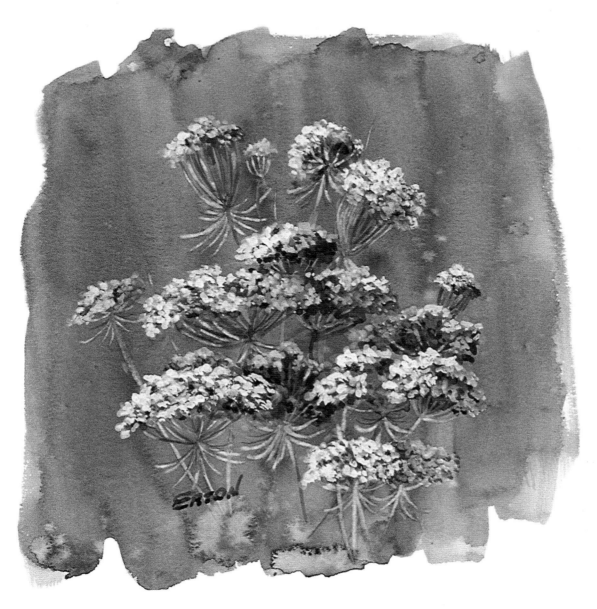

5 | Final Touches

Last, use full-strength gesso, your whitest white, and daub it onto the light-struck areas. A little goes a long way here. If you put too much in, you will lose the impact of the white. You can cover the pure white with muddy white if you get carried away. Add any final dark touches and sign your name.

FIT FOR A QUEEN • 6" × 6" (15cm × 15cm)

Gallery

Here are some additional finished paintings for you to enjoy. Maybe they will give you some ideas for compositions, too. Most of them use the basics explored in this book. As you can see, the techniques can be used in many different ways. Don't be afraid to experiment and put those miles on your brush. Happy painting!

Celebrate Beauty
This painting of oak leaves celebrates the beauty of autumn, the season that is my favorite.

FREE SPIRITS • 22" × 30" (56cm × 76cm)

Liberate Your Subjects
I took a lot of liberty with these gladiolus, picking some off the stem so you could see them more individually, and the intense red was a study in layering.

JUST GLAD TO BE HERE • 22" × 30" (56cm × 76cm)

Revisit Your Childhood
Most people call this flower Queen Anne's lace, but the gentleman who bought it said it was Grandma's lace and it took him back to his childhood.

JULY'S GIFT • 12" × 16" (30cm × 34cm)

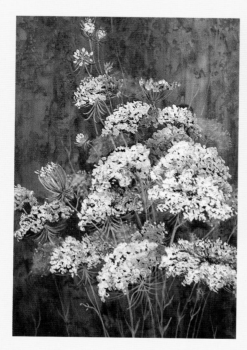

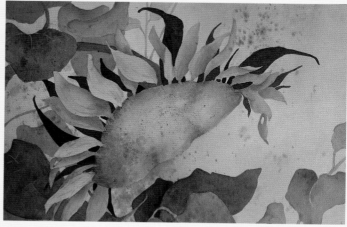

Free Your Mind
I like the way this sunflower floats freely in the sky.

SUMMER GOLD • 12" × 16" (30cm × 41cm)

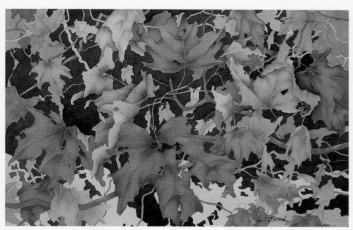

Enjoy the Dance

These maple leaves seemed to be dancing with the gentle fall breezes, enjoying those last golden days.

WIND DANCERS • 22" × 30" (56cm × 76cm)

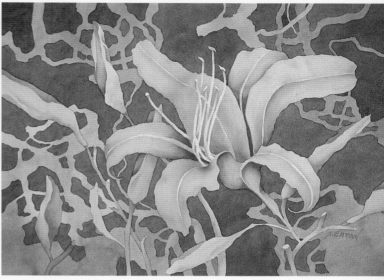

Define the Challenge

I wanted to try something in this beautiful color combination, but since yellow has a very short value range, it was a challenge to define the daylily properly.

TOUCH OF SUNSHINE • 12" × 16" (41cm × 30cm)

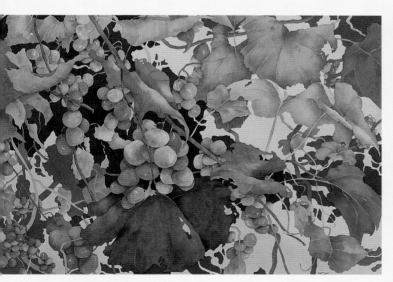

Capture Harmony

These ripening grapes haunted me until I painted them. The intricate background and the color choices changed and changed until I thought I could not make another painting decision. I hoped to catch the harmony in all the shapes and colors.

THE RIPENING • 22" × 30" (56cm × 76cm)

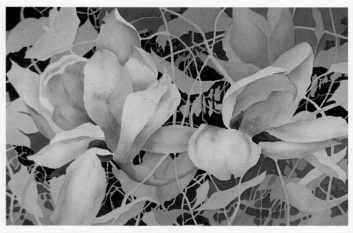

Experiment With Color Combinations

What an experiment these magnolias were. Almost all of the painting was done with various combinations of Winsor Red and Winsor Green. There is only a touch of blue in the very darkest areas.

DYNAMIC DUO • 15" × 22" (38cm × 56cm)

Conclusion

Painting is both a joy and a frustration for everyone. The act is always fun, but the end result sometimes falls short of what we had in mind. The creative act will always be that way, no matter how proficient you become. No one ever learned anything by producing success after success. The paintings that don't succeed are the ones that you learn the most from. Remember that you become a better painter by putting those miles on your brush. When the techniques become second nature and you don't have to think about them, you can concentrate on content and how to express it.

But by now I hope you have learned a lot about making a composition, understanding the technical aspects of painting and creating the colors that convey your ideas. If you can paint the shapes of flowers and leaves, you can paint any shapes. You're ready to move on to more complicated flowers—or to any other subject matter you like.

Best wishes!

Judy Eaton

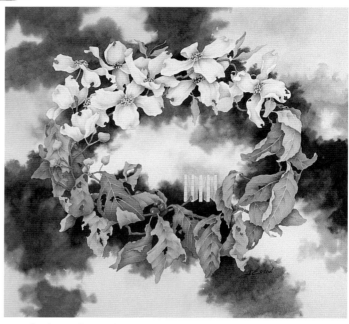

Speak Through Symbols

To me, the dogwood is so symbolic. Each season of its existence produces the next and the fall berries and buds lie sleeping for a while, gathering strength for the next life cycle. Each of us, too, gives life to the next generation—in our own season, in our own way. The pillars in the painting represent the Veterans' Memorial, with letters from service men engraved on the stone.

CIRCLE OF LIFE • 20" × 22" (51cm × 56cm)

HERE ARE SOME REMINDERS THAT I KEEP POSTED IN MY STUDIO:

Do

- Try new things all the time.
- Make painting time a priority.
- Read books and go to classes and workshops.
- Join a painting group.
- Make art for the pure joy of doing it!
- Paint your own personal vision. It's the only unique thing you have to give.
- Keep painting, keep painting, keep painting.
- Remember those two fantastic discoveries—

 —Anyone can learn to become proficient at the techniques.

 —Art is a thing of the head and heart, not of the hands.

- Celebrate the spirit of the creative act.

Don't

- Be intimidated by that white sheet of paper. It costs less than a movie!
- Think you can't paint because you didn't succeed. That's when you're learning.
- Wait for inspiration. The act of painting inspires best.
- Assume you can't do a particular thing. Try it. You'll learn something!
- Compare yourself to others. You are doing your own thing!

Index

Here's more *fun* & *easy* art instruction from
NORTH LIGHT BOOKS!

Packed with insights, tips and advice, *Watercolor Wisdom* is a virtual master class in watercolor painting. Jo Taylor illustrates every important technique with examples, sketches and demonstrations, covering everything from brush selection and composition to color mixing and light. You'll learn how to find your personal style, work emotion into your work, understand and create abstract art and more.

ISBN 1-58180-240-4, hardcover, 176 pages, #32018-K

Create your own artist's journal and capture those fleeting moments of inspiration and beauty! Erin O'Toole's friendly, fun-to-read advice makes getting started easy. You'll learn how to observe and record what you see, compose images that come alive with color and movement and make a travel kit for creating art anywhere, at any time.

ISBN 1-58180-170-X, hardcover, 128 pages, #31921-K

Beautifully illustrated and superbly written, this wonderful guide is perfect for watercolorists of all skill levels! Gordon MacKenzie distills over thirty years of teaching experience into dozens of painting tricks and techniques that cover everything from key concepts, such as composition, color and value, to fine details, including washes, masking and more.

ISBN 0-89134-946-4, hardcover, 144 pages, #31443-K

Create startling works of art that glow with color and light! Jan Fabian Wallake shows you how to master special pouring techniques that allow pigments to run free across the paper. There's no need to worry about losing control or making mistakes. Wallake empowers you to trust your instincts and create glazes rich in depth and luminosity.

ISBN 1-58180-161-0, hardcover, 128 pages, #31910-K

These books and other fine North Light titles are available from your local art & craft retailer, bookstore, online supplier or by calling **1-800-448-0915**.